Manga Art for Intermediates

A Step-by-Step Guide to Creating Your Own Manga Drawings

CREATED BY

DANICA DAVIDSON

RENA SAIYA

Skyhorse Publishing

Skyhorse Publishing books may be purchased in bulk at special discounts for
sales promotion, corporate gifts, fund-raising, or educational purposes. Special
editions can also be created to specifications. For details, contact the Special
Sales Department, Skyhorse Publishing, 307 West 36th Street, 11th Floor,
New York, NY 10018 or info@skyhorsepublishing.com.

Skyhorse® and Skyhorse Publishing® are registered trademarks of Skyhorse
Publishing, Inc.®, a Delaware corporation.

Visit our website at www.skyhorsepublishing.com.

10 9 8 7 6 5 4 3 2 1

Library of Congress Cataloging-in-Publication Data is available on file.

Cover design by Jane Sheppard
Cover illustrations by Rena Saiya

Print ISBN: 978-1-5107-2952-0
eBook ISBN: 978-1-5107-2953-7

Printed in China

Contents

Introduction

Manga has become a worldwide phenomenon. Fans of Japanese comics and animation can be found around the globe, and many of them want to express their love for these art forms by drawing in the same style.

This book is the sequel to *Manga Art for Beginners*. *Manga Art for Beginners* was a more basic book on showing newcomers how they could have fun drawing their favorite manga character types, and it made the point of using more steps than average how-to-draw-manga-character books, enabling readers to better see the creative steps. *Manga Art for Intermediates* continues where that left off, but also has more to offer.

In this book, you'll find many beloved and popular manga character types, drawn in special detail and enlarged, so you can really see what's happening. *Manga Art for Intermediates* assumes that, whether or not you have read *Manga Art for Beginners*, you have some basic knowledge of drawing. By learning how to draw various characters, the experiences can be your "data base" of character design and it will be helpful when you create your own characters. So it also teaches drawing on a more professional level and talks about how manga is drawn in Japan. The art was completed by professional artist Rena Saiya from Japan; she has a background in both professional artwork for top Japanese publishers and in teaching students how to draw in the manga style. With the knowledge of what works well, what Japanese publishers look for, and what real professional artists in Japan do, *Manga Art for Intermediates* invites you to pick up your pen (or your computer or tablet) and experience the beautiful world of manga character drawing.

Getting Started

Tools Needed for Making Manga

You have different options for making manga—from software to pen on paper. Software will typically give you what you need for the different aspects of making manga, like helping you with screentones and colors. If drawing on paper, you can use pencil, and finish it up by inking it with art pens, easy-to-find ballpoint pens, or special pens used by professional *mangaka* (manga creators) in Japan, depending on what you want and what your budget is. This section will talk about some of those options.

Beginning with a Sketch

All manga drawings start with a sketch. Any sort of paper would work. Plenty of high school students draw manga characters on printer paper or notebook paper, but professionals use thicker paper for their work. These can be found in sketchbooks sold in art stores and sometimes in retail stores in their office supply section. In Japan, the type of paper suitable for drawing monochrome manga (meaning manga using one color, like black) is called "kent paper" and packed kent papers are sold as "manga manuscript paper" at art shops. And, like so many other things these days, they can also be bought online.

In Japan, artists sometimes use mechanical pencils with blue lead for the preliminary drawing where they put down the basic outline of the character. A mechanical pencil with regular gray lead works as well. In this book, you'll see blue for the preliminary drawings, then a gray pencil for more detailed penciling, followed by inking. This is one of the typical methods of manga character drawing used in Japan, and it's suitable for learners at beginner or intermediate levels.

Mechanical pencils aren't used as much in America, but in Japan, they're prized for their clean, straight lines and their affordable prices. In manga, you often see characters using mechanical pencils, and there's a reason for that!

If you don't have blue or gray lead for a mechanical pencil, a regular wooden pencil can also work, but you have to make sure it's properly sharpened for the kind of lines you want to make.

A ruler is also useful when drawing straight lines, like background buildings. It can also help you measure distance.

Pens and Inking

Once the drawing is done, then it is time for inking. On paper, there are different options for how you want to ink, and sometimes Japanese *mangaka* and American comic book inkers use different materials.

A calligraphy dip pen called Speedball #102 is popular among professional comic book inkers in the United States. Other artists use Pilot ballpoint pens; these aren't common in Japan, and in many cases, publishers there do not approve of using ballpoint pens. So a ballpoint pen is not good if you want to show your work to a Japanese publisher or in a Japanese competition. However, ballpoint pens are easy to find, and if the art is just for fun or not for professional manga publishing, then they are fine to use.

Specialty art pens can be bought in art stores, in some stores that sell office supplies, and online. Sometimes you can buy a pack of pens (as opposed to one pen that holds different nibs). If you notice numbers on the pens like "01" or "08," these are telling you how thick the ink line will be. Getting a starter pack of pens like this can be a good way to get started and let you experiment with ink. Waterproof ink is recommended.

In Japan, the most common types of ink are Pilot Drafting Pen Ink and Kaimei-Bokuju. Pilot Drafting Pen Ink, which is also easy to find in the United States, dries quickly and is waterproof.

While pens work for the basic outlining of characters, a brush is used for filling in black spaces, like hair. Raphael series 8404 #2 or #3, Sharf brushes, and the Japanese Kuretake brush pen are all used by American inkers. Kuretake brush pens were originally made for calligraphy and later become popular with manga. Felt nibs are often not waterproof, though they are also very useful for coloring in black hair, but there is also the option of brush nibs. Likewise, it's not rare for a packet of art pens to include a brush pen. We will discuss more about inking in the following pages.

What If I Make a Mistake?

Have a good eraser on hand for any mistakes made while using your pencil. If you mess up while working with ink, don't worry. It happens to everyone from time to time, and there are options. Many *mangaka* in Japan use Dr. Ph. Martin's Bleedproof White as you might use Whiteout because it takes away the ink without ruining the picture.

Software Options

On a computer, things like drawing and inking can be done through special software.

Manga Studio EX 4 (also called Comic Studio EX 4.0 in Japan) has been popular among Japanese manga artists for its high function of creating monochrome manga of multiple pages. Though it's already finished selling in Japan, it still has a high reputation.

Manga Studio 5 (also called CLIP STUDIO PAINT PRO) is suitable for drawing colored or monochrome illustrations and single-page manga.

The advanced version of it is Manga Studio EX 5 (also called CLIP STUDIO PAINT EX). In addition to all of the functions of Manga Studio 5, it has functions to create colored or monochrome manga of multiple pages and for animation.

Screentones can be done with software, but we will also show you how to do screentones by hand. Because not everyone has access to screentones, there aren't many examples of them in the book.

If you are interested in the software, you can search for more detailed information on the Internet and can choose the most suitable one for you.

A Final Thought

All of this might sound a little overwhelming, but it doesn't have to be. It simply shows that you have different options for your drawing, depending on whether you just want to draw for fun or draw in the style of professional *mangaka* in Japan. Trying out different techniques can also help you find what you like best when you're making your own manga drawings.

A Note on Proportions

Manga characters have a very distinct look. So if you're an artist who is new to manga or just coming here after *Manga Art for Beginners*, here is a brief reminder on manga proportions.

One important aspect is the legs. In manga, legs are longer than on real humans. You don't want to make the legs so long that they look absurd, but you do want to stretch them a little.

Manga is famous for having characters with large eyes, but not all characters in manga do. Eye size depends on the type of character you want to draw. Younger, innocent, and more girlish characters have bigger, dewier eyes. On the other hand, if you want to show that a character is serious, dangerous, or mature (or any combination therein), their eyes will be smaller to give this effect.

Characters usually have small noses, which, depending on the angle, can be drawn like a little triangle or just a line with a brief curve at the end.

How Characters Will Be Drawn

For the rest of the book, we will follow these steps:

1. Draw a thin, basic outline of a body. If you have a blue pencil, you can use it. If not, you can draw by pencil very thinly.
2. Draw a more detailed sketch using pencil on the basic outline. Create details such as the face, hair, and clothes.

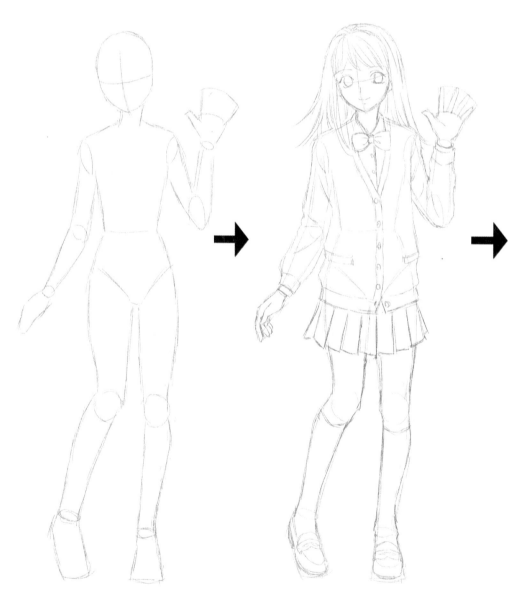

3. Ink on the detailed sketch.
4. After making sure the ink has dried, erase the basic outline and the detailed pencil sketches using an
 eraser. If you have some screentones, you can put them on the gray parts of the character. Instead
 of dark gray, you can paint it in black. In that case, black parts should be painted before you work on
 screentones.

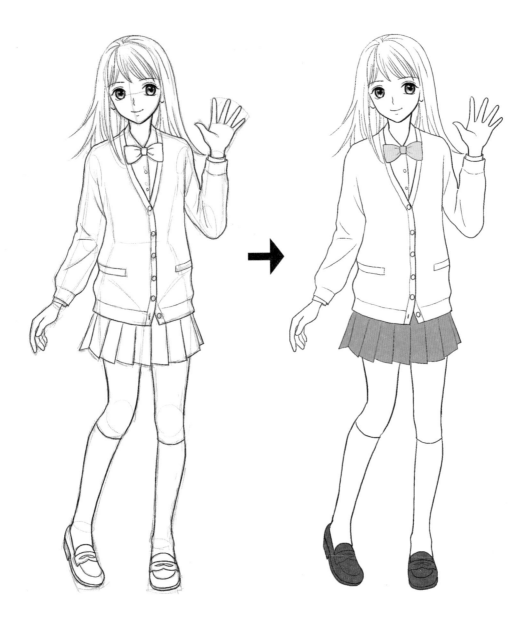

How to Use Japanese Dip Pens and White Color

You might not be so familiar with dip pens. But if you get used to using them, you can draw smooth lines suitable for manga. Usually such pen nib holders and pen nibs are sold separately. There are some kinds of nibs, such as G pen (search online with the word "manga" included to get the right kind), maru pen, and kabura pen (spoon pen), and school pen that are popular in Japan and are available in America. You can attach a favorite one to a pen nib holder. But a maru pen's shape is rather different from the others, so in many cases you need to buy a pen nib holder for it.

G pen

Maru pen

Pen nib holder

G pens are the most popular pen and the second is the maru pen. G pens can draw both thicker lines and thinner lines in one smooth stroke, as you can see in the right picture. When characters are drawn by such lines, it gives the characters a kind of vitality. Depending on the pressure, we can easily change the thickness of the lines. Maru pens can draw like this too, but in a thinner and more delicate way.

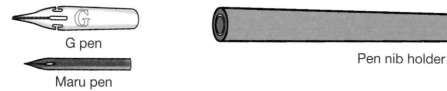

When you start to use a new pen nib, please completely wipe off the thin oil which covers the surface of the pen nib. Use tissue paper, unless the ink forms small balls when you dip the pen into ink.

Sometimes you need to wipe off the ink on the pen nib while you are inking. If not, the ink sticks to the pen nib and the lines become thicker and not clean. Instead, you can also try washing the nib using water in a small bottle. Just wipe off the water.

As for white color, Japanese artists usually put a small amount of water and white on a small plate and mix it, adjusting the thickness of it to neatly correct mistakes. In Japan, "menso brushes" are often used as the ones for white painting, and these are also available in America. A menso brush has a very keenly pointed and thin tip. It's convenient for drawing thin lines. You can also use common brushes with these kind of tips.

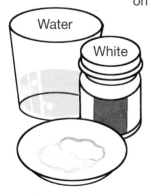

Water

White

Small Plate

How to Paint Black Hair Using Brushes

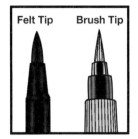

Felt Tip Brush Tip

In Japan, when black hair is painted on a character, a brush pen is used most often. They contain ink in their barrels. Generally speaking, the ones with a felt tip are not waterproof, so be careful not to spill water on it after you paint. For many learners, a felt tip is easier to use when painting hair.

You can also use a common brush, but the shape of the tip should be pointed, as shown in the illustration below.

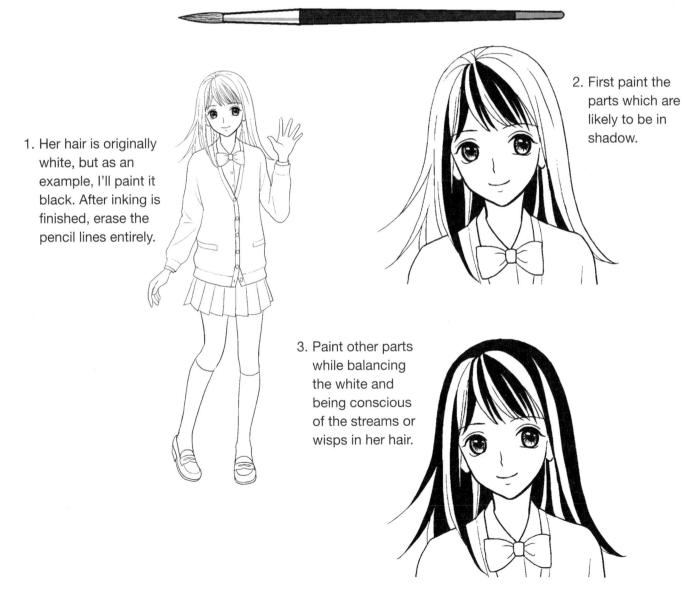

1. Her hair is originally white, but as an example, I'll paint it black. After inking is finished, erase the pencil lines entirely.

2. First paint the parts which are likely to be in shadow.

3. Paint other parts while balancing the white and being conscious of the streams or wisps in her hair.

4. Using a brush or a brush pen, begin to paint her bangs. In order to make this clear, the newly painted part is red.

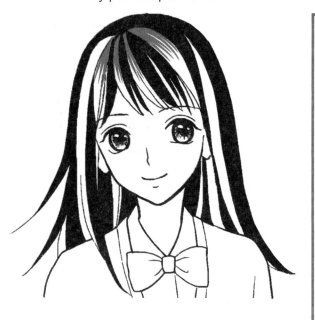

5. When you paint the lower part of the bangs, you can change the angle of the paper freely in order for you to paint more easily.

When leaving a shining white part, draw a series of short strokes like the picture above. Each stroke should have a pointed end as shown.

6. Paint the rest of the white parts while leaving shining parts. You can change the angles of the paper freely each time you paint a new part. The length of the strokes varies depending on the parts. On some strokes, both ends are pointed.

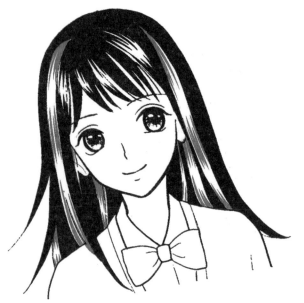

7. After you paint all parts, if needed, you can erase the sticking-out parts or add several white lines using a pen or thin brush.

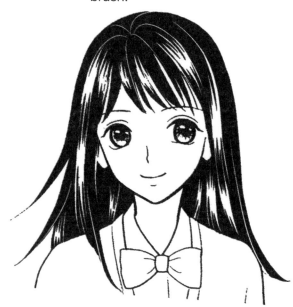

How to Stick Screentones to a Picture

There are various kinds of screentones, but the ones with printed small dots are the most basic. They are placed on translucent mounts. When you cut screentones, be careful not to cut the mounts or the pictures you want to stick them to. A knife used only for screentone cutting is convenient, but you can also use common cutter knives. Using software will also help with screentones.

Screentone

Mount

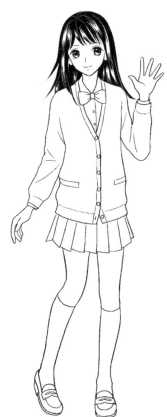

After you've finished inking, erasing pencil lines, and painting black parts, work on screentones.

1

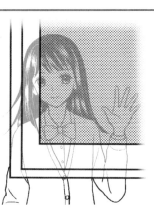

Put the screentone on the picture with the mount to stick it to her bowtie.

2

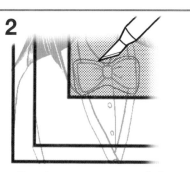

Cut the screentone a little wider than the bowtie, like the red line. Be careful not to cut the mount or the picture. After you are finished cutting, peel the cut part off the mount.

3

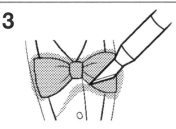

Put the peeled screentone on the bowtie. Rub it lightly with a screentone rubbing tool or your nails. After it's been lightly adjusted, cut off the excess screentone.

4

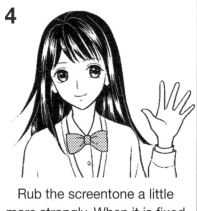

Rub the screentone a little more strongly. When it is fixed completely on the picture, it's done!

Shojo

Shojo means "girl" in Japanese and refers to a style of manga aimed for teenage girls. Often the heroines of these stories are teenage girls themselves, like this one.

1. Start with the rough sketch of her body, possibly using blue lead. Draw these lines across her face to help you with positioning her facial features. Note that the waist will turn in more than a man's waist would.

2. From here on, use the basic outline to guide you. Begin to fill out the face. Draw the line of her face and the first basic circles for her eyes with the pupils. Gently draw in the nose and mouth. You can use gray lead for these details and as you continue. Try not to draw too thickly at this phase.

3. Begin on the hair. It's important to find a starting point, because all hair will sweep away from here. Add in the bangs, keeping in mind how they should flow from the center point.

4. Continue to draw in the hair. Again, make sure that the hair always flows from the center point. This will give the hair a flowing, natural look.

5. Start drawing her coat. With a circle and two bigger loops, you can create the bowtie at her collar.

6. Keep drawing the coat, adding in lines and buttons.

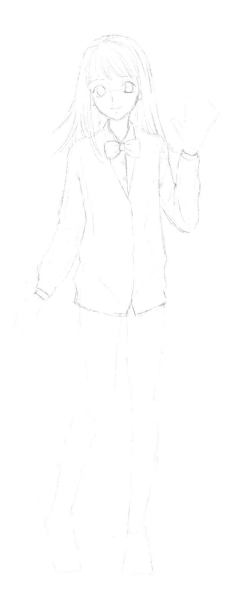

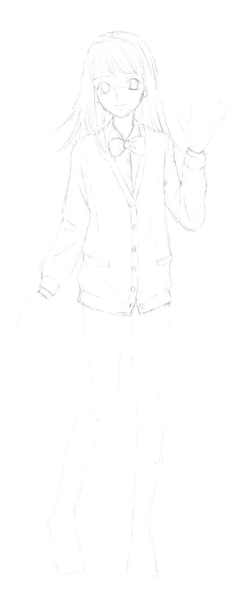

7. Draw in the hands. Hands can be tricky, so note the spacing of fingers on the left hand (your right). Her right hand is curved, so the forefinger will be the most visible, the other fingers curled behind it.

8. Draw in her skirt, doing even lines for the pleats.

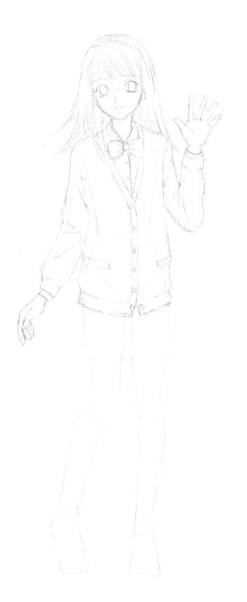

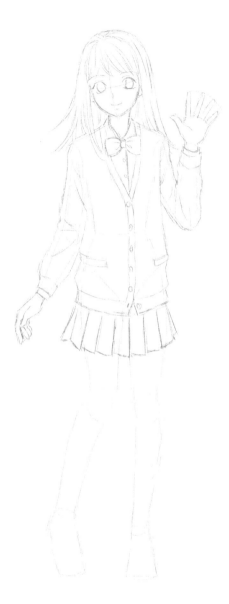

9. Draw her legs, socks, and the outlines of her shoes over the original blue sketch.

10. Draw the details on the shoes.

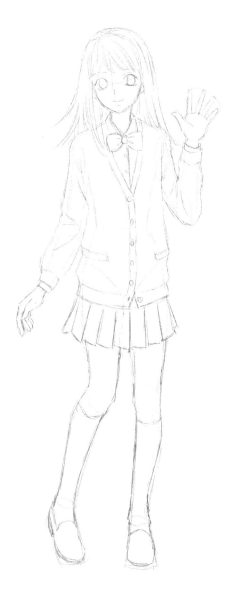

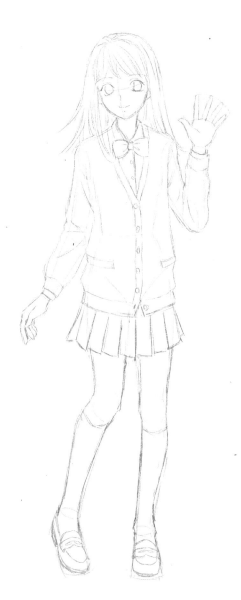

11. Once you are happy with your drawing, it is time to ink. You can start with inking her face first, working on her eyes, nose, and mouth.

12. Draw the ink outline for her hair. Make sure you use a finer pen or pen nib for the hair so that the lines here are thinner.

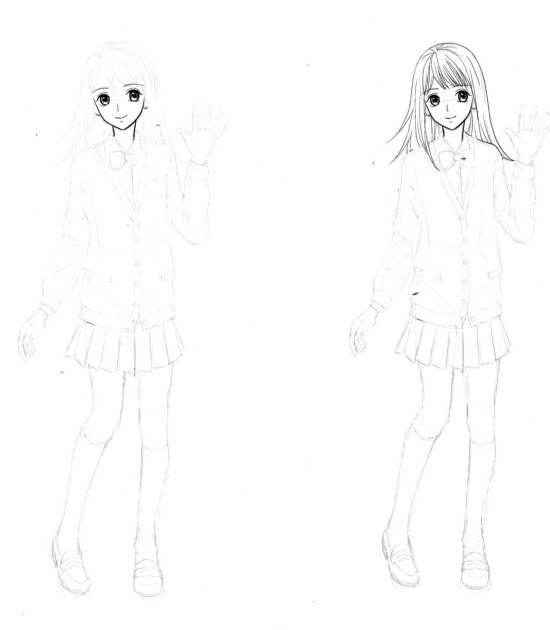

13. Ink her coat, undershirt, and bowtie. You'll want the ink for this to be thicker than the ink used for her hair.

14. After adding in lines and buttons by inking, start to ink the creases in her clothes. This will give her more depth and make her look more realistic.

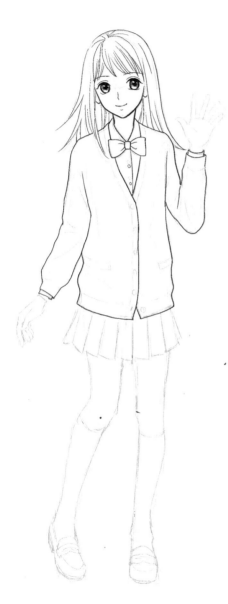

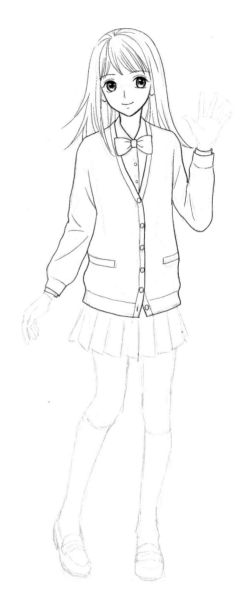

15. Continue your inking, outlining her hands and skirt.

16. Outline the rest of her body with ink. Note the designs on the tops of her shoes. With all this inking, her image is really going to pop on the page. Once the inking is done, then erase the original pencil underneath. You can choose to use colors or screentones on her clothes if you want.

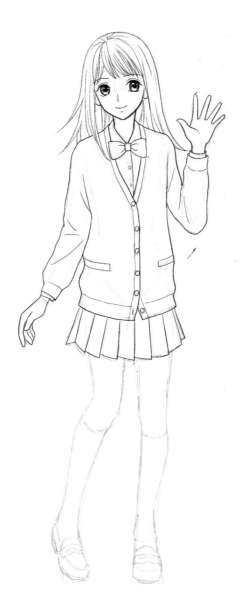

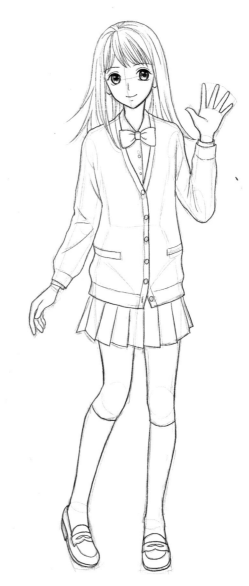

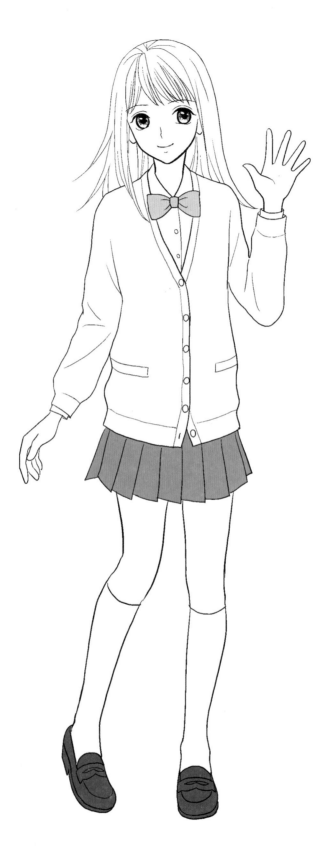

Kendo Player

Kendo is a popular martial art in Japan and stories about it often show up in manga. This kendo player is holding a bamboo blade, called a *shinai*, which is used like a sword.

1. Start with the outline of the body shape and weapon.

2. Draw in the outline of his *hakama*. *Hakama* start at the waist and go to the ankles. They are loose, plaited pants that can look like skirts from some angles.

3. Begin drawing his face and neck line. His small eyes give him the look of a serious and mature character. If he were currently playing, he would have something called a *men* to cover and protect his face.

4. Continue to work on his head. When you draw in his hair, give it a few sprigs.

5. Draw his *uwagi*, or jacket. It will always fold from left to right over the front of his body.

6. Draw in his hands so that they are looped around the bamboo blade.

7. Draw in the rest of his clothing. Notice how his pants are pleated in the front but smooth on the side.

8. Now that you have taken care of his clothes, draw in his bare feet.

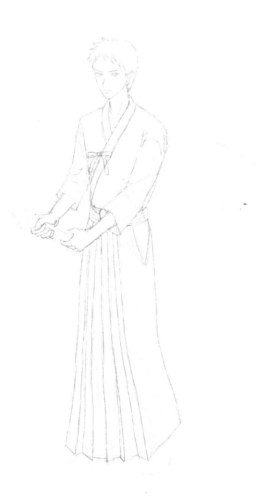

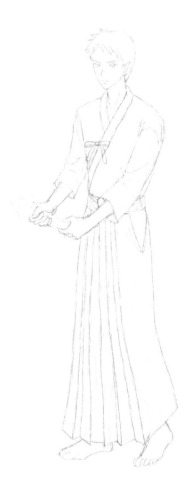

9. Fill in the detail for the bamboo blade. There will be a line going through it except for the very tip and one spot in the middle; use a ruler for this step. In addition, be careful of the circled part of the blade. The width is the largest in that area.

10. After you are happy with your drawing, start inking. Use a delicate nib around his eyes because it is such a small area.

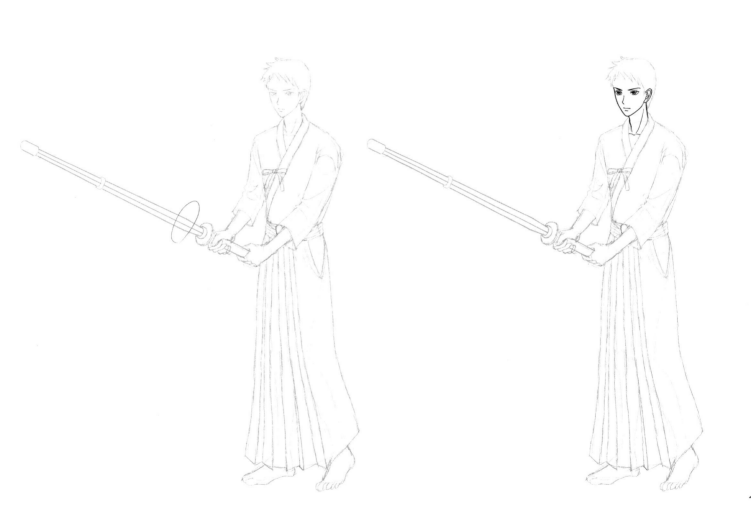

11. Ink his hair and his jacket. Make sure you ink the creases in his sleeves to make it more realistic.

12. Ink his arms and hands.

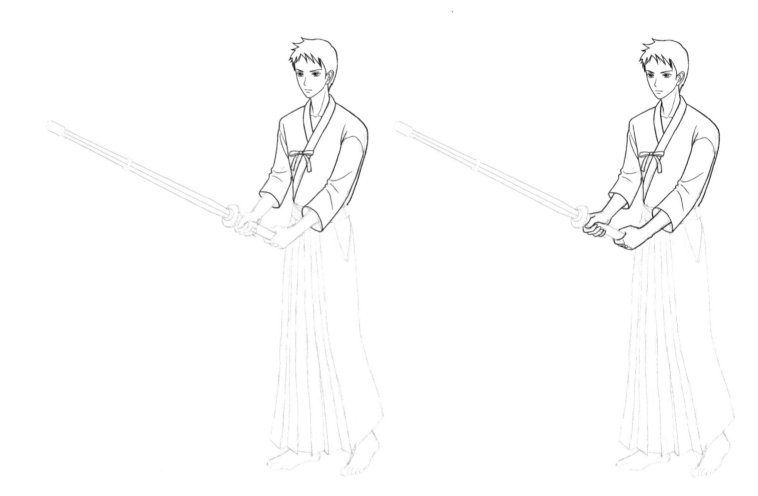

13. Ink the outline of his pants, including the pleats. 14. Ink his feet.

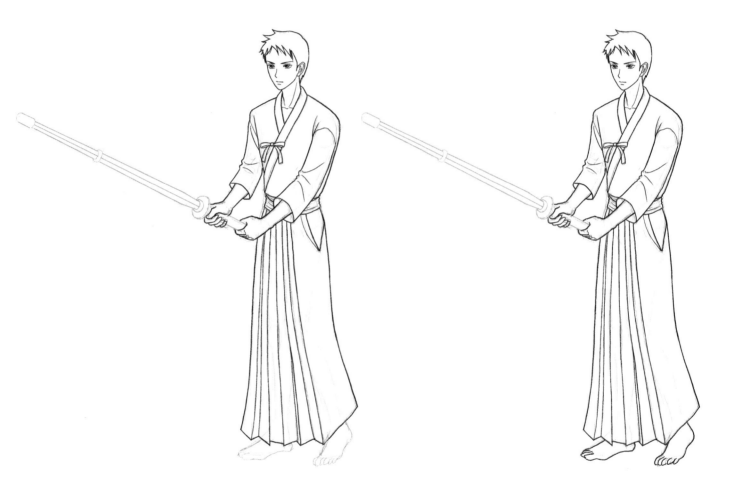

15. Finish the inking process by inking his bamboo blade. Use a ruler to make sure your lines are straight.

16. Once all of the line inking is done, erase all blue and gray pencil lines and you can continue to color him in how you'd like.

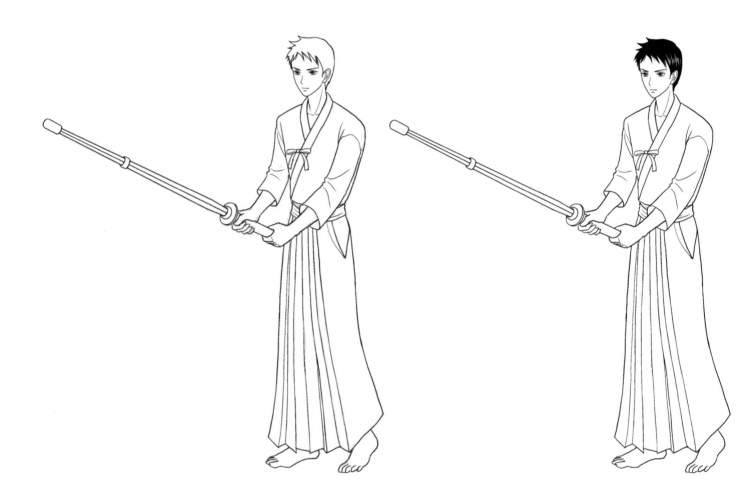

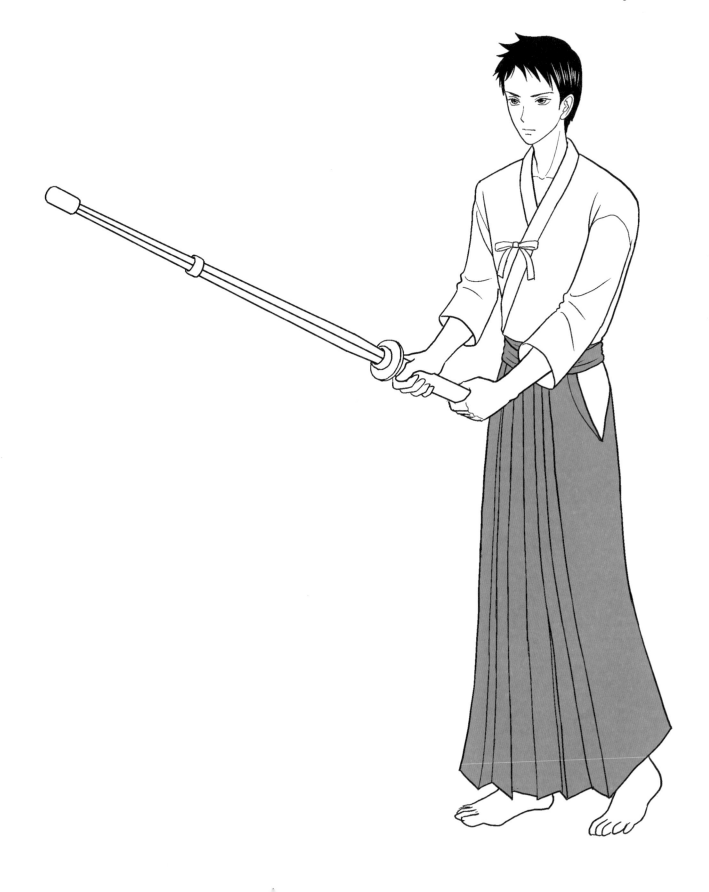

Gothic

Horror is a popular manga genre, and gothic is a subgenre of that. Think of popular artists like Kaoru Yuki and Yana Toboso, author of *Black Butler*. Here is a girl who would fit perfectly in the pages of a moody gothic manga.

1. Start with the outline. Notice how her arms are slightly outstretched and she has one leg in front of the other.

2. Do some preliminary lines for her long hair and long, jagged skirt. Put circles to the sides of her head.

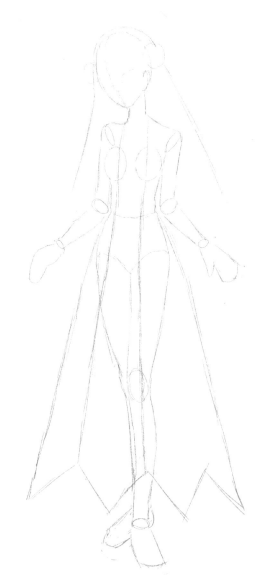

3. Begin to draw her facial features like her face line and her small nose, mouth, large eyes, and eyebrows.

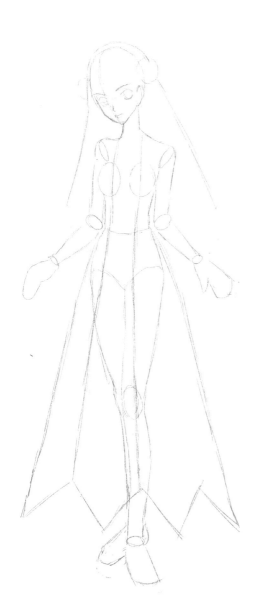

4. She'll be wearing a frilly headband over her hair. Make jagged sketches like teeth for the frills.

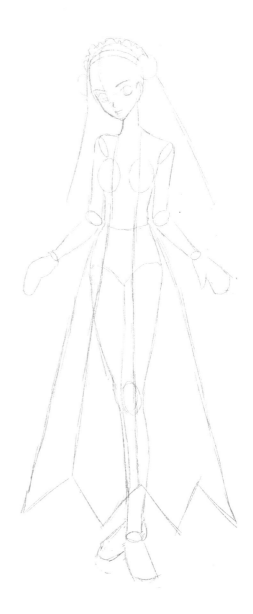

5. Once you have the basic outline of the headband done, draw in lines for creases.

6. The circle next to her headband is going to be a rose. In the middle of the circle, draw another circle with two curved lines next to it. It will look a bit like an eye. This is the start of the rose.

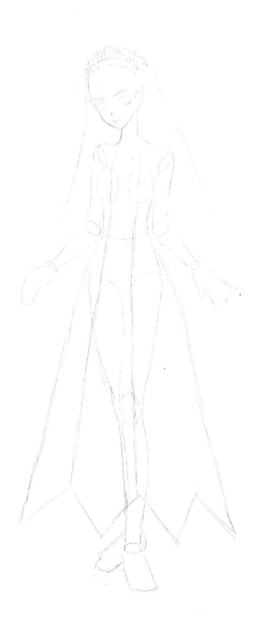

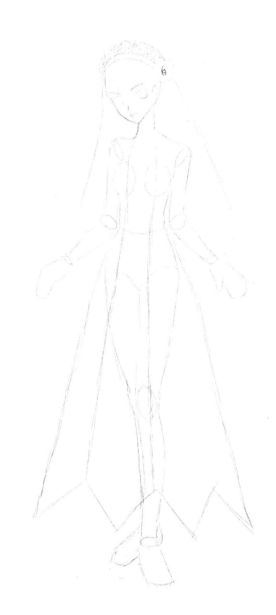

7. Continue the pattern for the rose.

8. After that pattern is done, you'll be drawing more of the petals. Watch how these little loops move from line to line.

9. You're almost done with the rose! Make an outer layer of petals, looping out and back in from the lines you've already drawn.

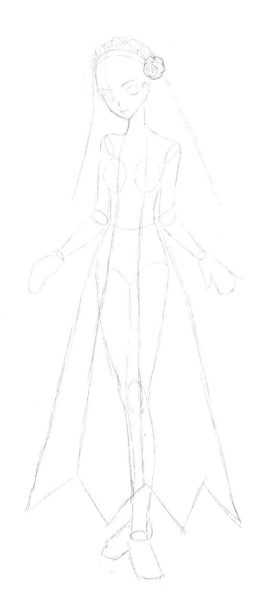

10. Turn your attention to the other circle by her headband. Because of the angle, this rose will be drawn a little differently. You're going to start by making two small shapes, with a little indentation in the middle of the top one.

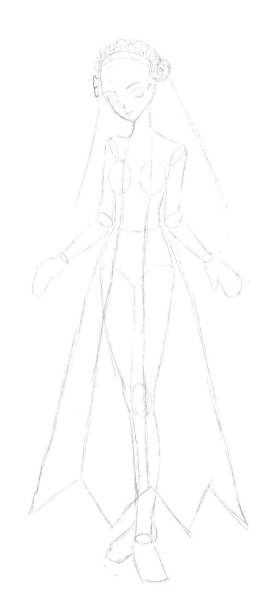

11. Next, draw in a middle, larger petal with a point, and two smaller petals on each side. That will finish the second rose!

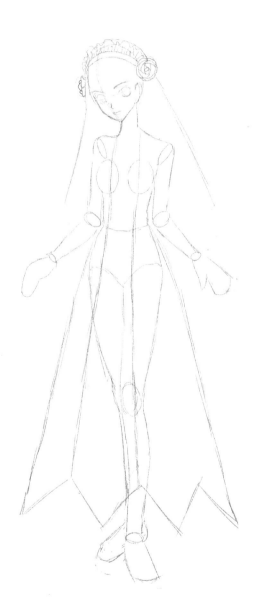

12. It's time for more detail on her hair. Have it fall down in long and flowing wisps. Her bangs will have many small lines over her forehead.

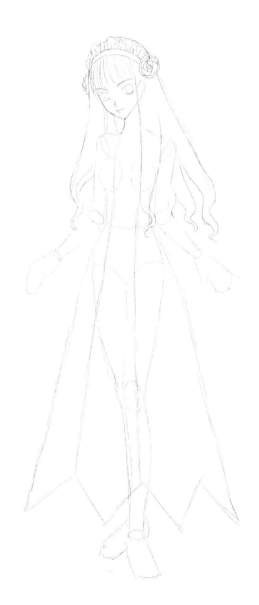

13. Turn your attention to her pretty dress. With two lines, a small choker goes across her throat. Her dress is shoulderless, but the sleeves are long and end in triangles. X-shaped straps go over her chest, and add the neckline.

14. Fill out her skirt.

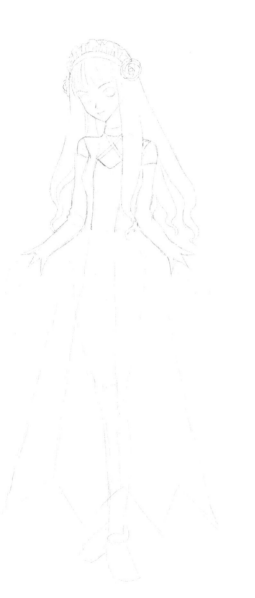

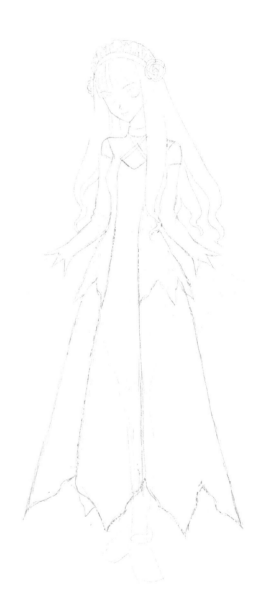

15. Once her skirt is done, draw in her hands, using the original basic outline to gauge their size and position.

16. Draw her shoes. They will be clunky and a little curved on the top.

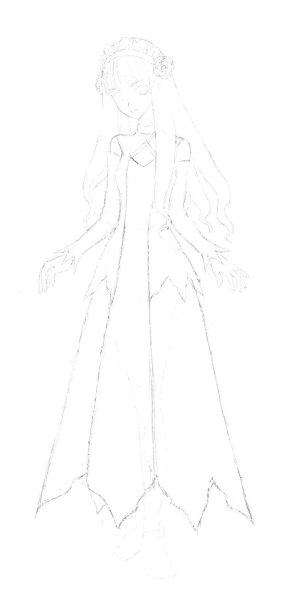

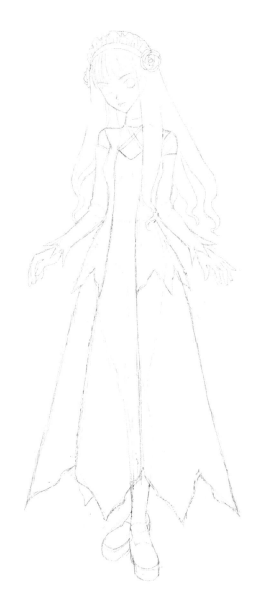

17. Finish her shoes by drawing laces up her legs.

18. It's time to start inking. Start with her face.

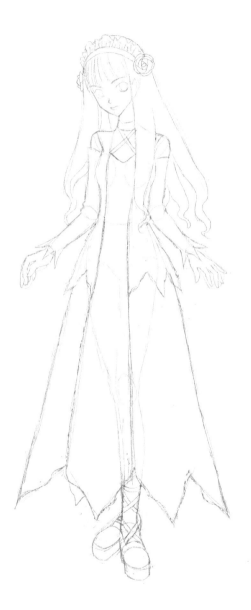

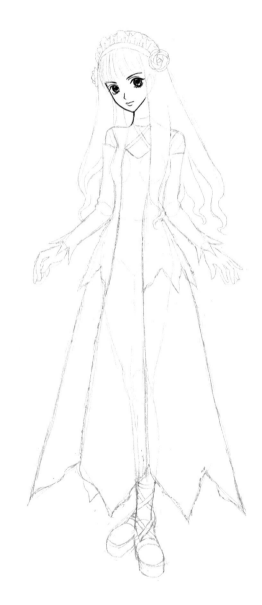

19. Ink her headband and roses, going carefully
 over the small lines there.

20. Ink her hair and her bangs.

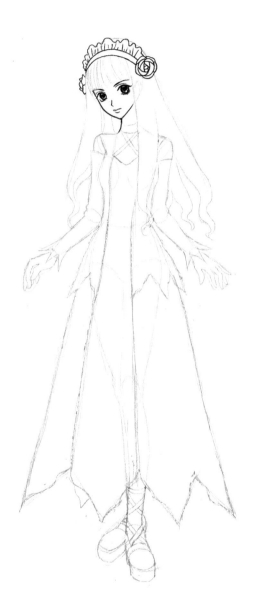

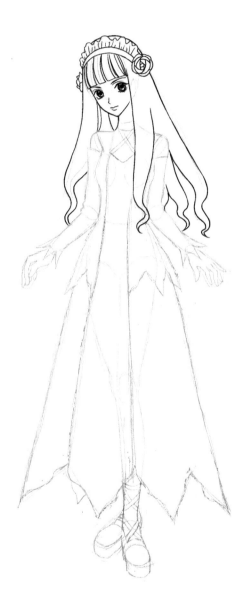

21. Begin inking her clothes. You'll want to use a pen with thicker ink than the pen used for her hair and facial features to achieve the desired effect.

22. Finish inking her dress.

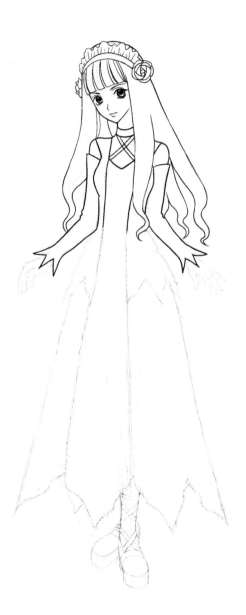

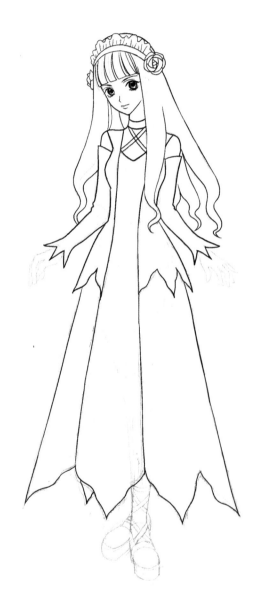

23. Ink her hands.

24. Ink her shoes and her laces. Be careful when working on the laces so that the ink looks natural, and you can't tell when you're lifting the pen.

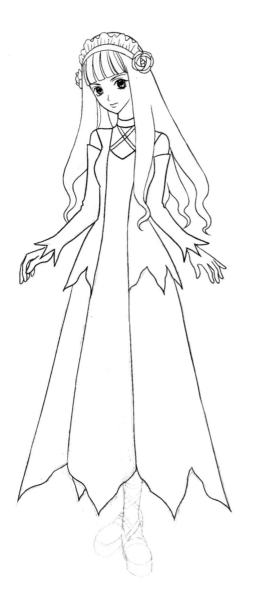

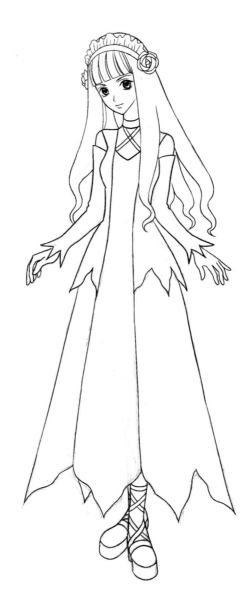

25. Erase the blue and gray pencil lines. With a brush (or software), you can color in her hair, leaving white ripples to show where the sun catches on it.

26. Likewise, use your brush or software to color her whole dress black.

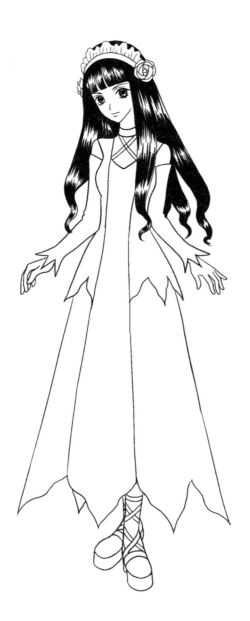

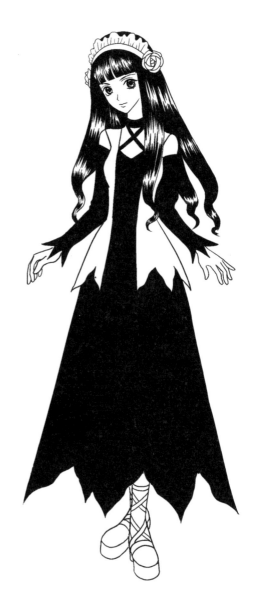

27. Ink in her shoes, with white ripples on the front to show light.

28. Finish the job by inking in her laces and the toes of her shoes. From there, you can also use screentone to give her more detail, if you want.

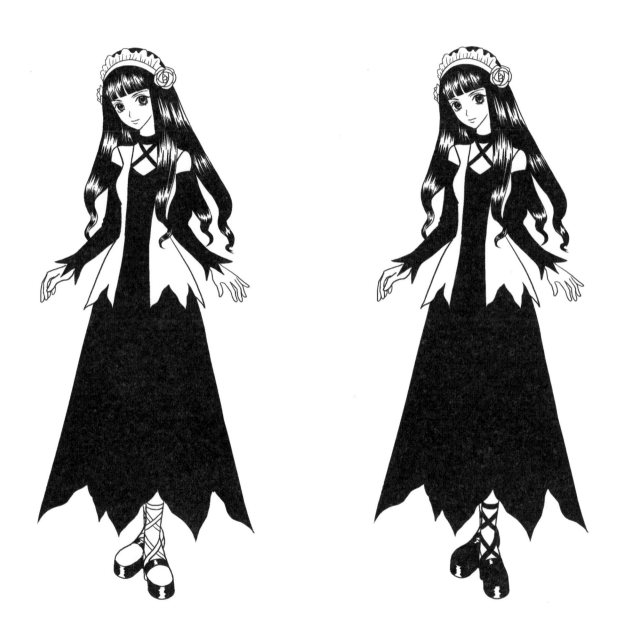

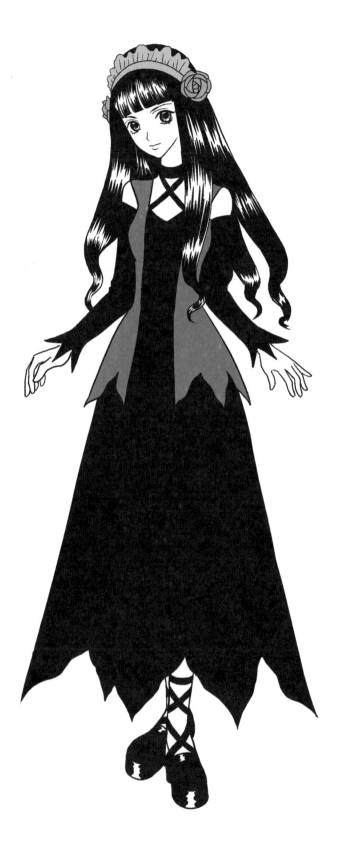

Groom

Romance is a popular manga genre, and you will see plenty of weddings in these. For romantics at heart, here is a groom in traditional Western-style clothing.

1. Begin with the general outline of a man's body type.

2. Begin to draw his face. In manga, eye size says a lot about a character. These smaller eyes make him look mature and strong.

3. Finish his face and work on his hair. His hair is parted from where the center line on his face is. All of his hair will move away from this part.

4. Draw his coat. On his left side (your right) the coat will appear to flare up a little. Put creases by his shoulders and elbows.

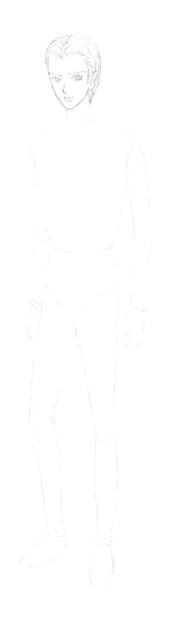

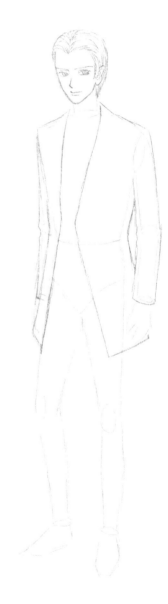

5. After you've drawn the general outline of his suit, draw the lapels and pockets on his jacket. Then draw in his bowtie.

6. Draw in his undershirt and waistcoat. Line up the buttons an equal distance apart. (You can use a ruler to help you with this if you want.)

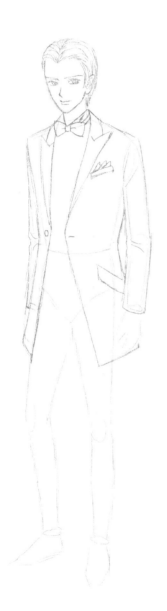

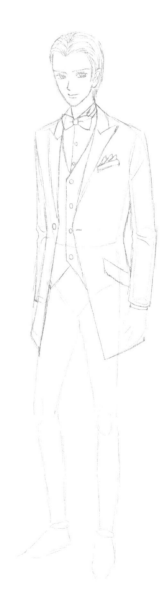

7. Draw his hands, using the original outline to help you with their size and placement.

8. Draw his pants. His right leg (your left) will have more creases because it's slightly lifted.

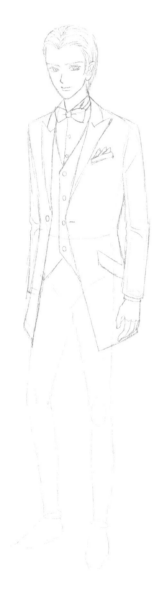

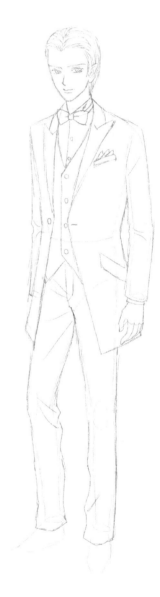

9. Draw his shoes. Notice the line at the bottom to differentiate between his heels and the tops of his shoes.

10. Start to ink his face, using a delicate pen tip for the fine lines.

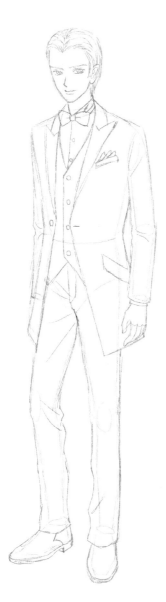

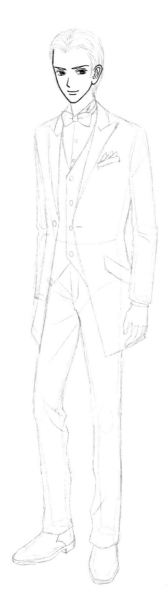

11. Ink his hair. As with his face, use a delicately tipped pen for finer lines.

12. Begin to ink his clothes, using a pen that makes thicker lines.

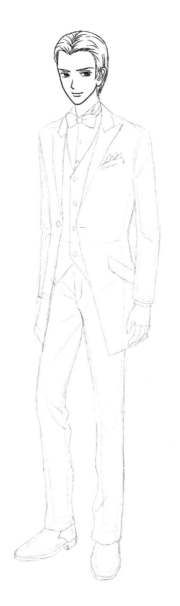

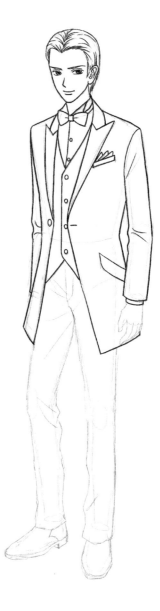

13. Ink his hands.

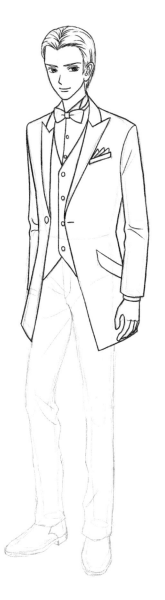

14. Finish inking his clothes.

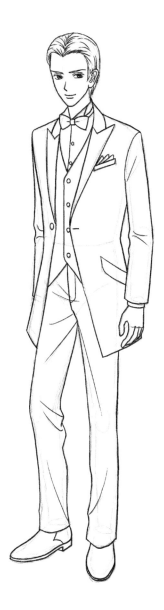

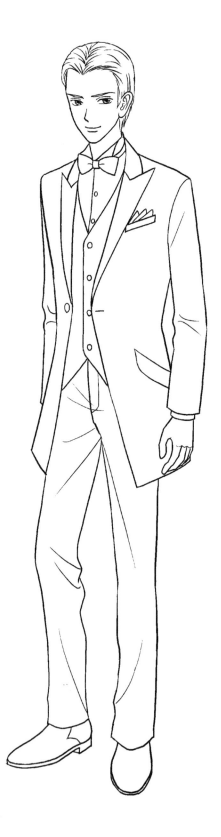

Bride

If there's a groom in romantic manga, there's probably going to be a bride. (Boys Love couples will be covered later in this book.) This bride is dressed in Western style clothing to go with the groom.

1. Start with the outline. You won't see her legs in the final picture, but doing this outline helps with proportions and knowing where to draw things.

2. Once her outline is there, do a basic outline for her extravagant dress and veil. Watch how the layers move up her skirt.

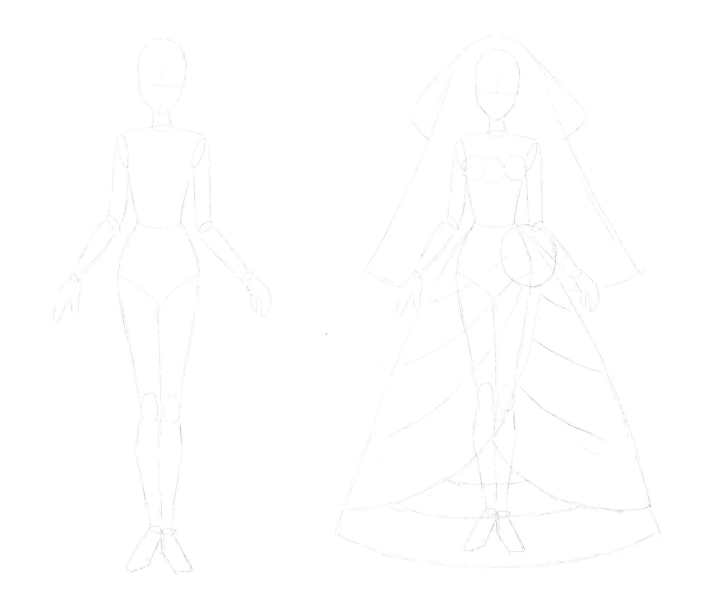

3. Draw her face. She'll have large eyes, larger than the groom's.

4. Her hair is a little complicated, so start with her bangs and the front of her hair falling by her throat.

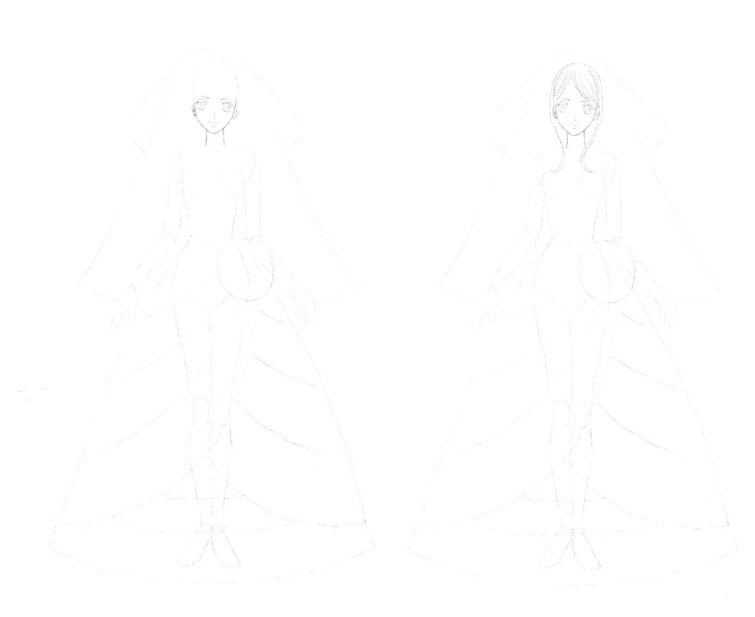

5. Continue drawing her hair by creating a band shape over her head. Draw little lines over it.

6. Behind the band of hair, draw in twirling loops for her curls.

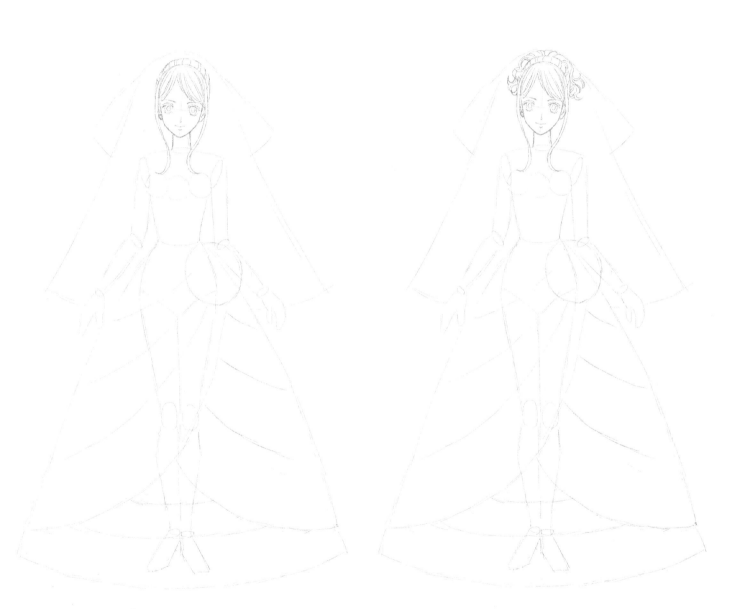

7. Draw the off-the-shoulder sleeves of her dress, putting creases in the middle.

8. Draw gloves going almost up to her elbows. The gloves will slant at the end.

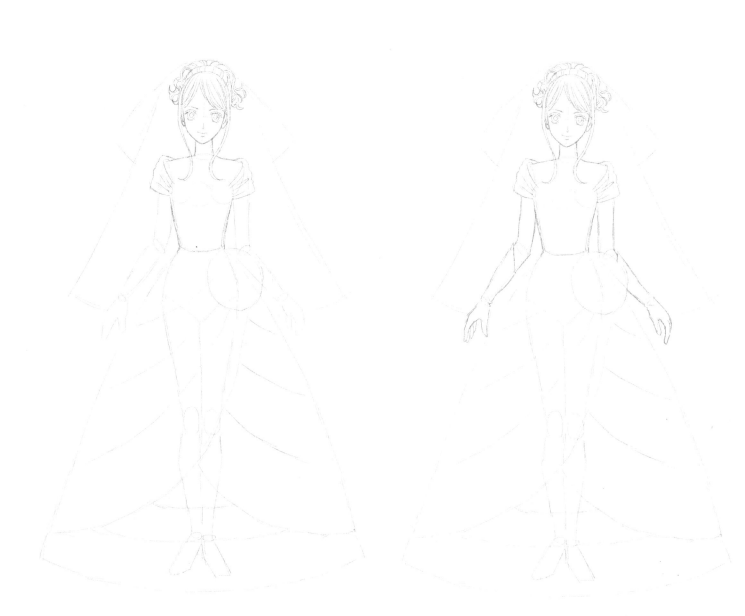

9. You can start to add more detail to her long, flowing skirts.

10. Draw more details to her veil, giving it very light crease lines.

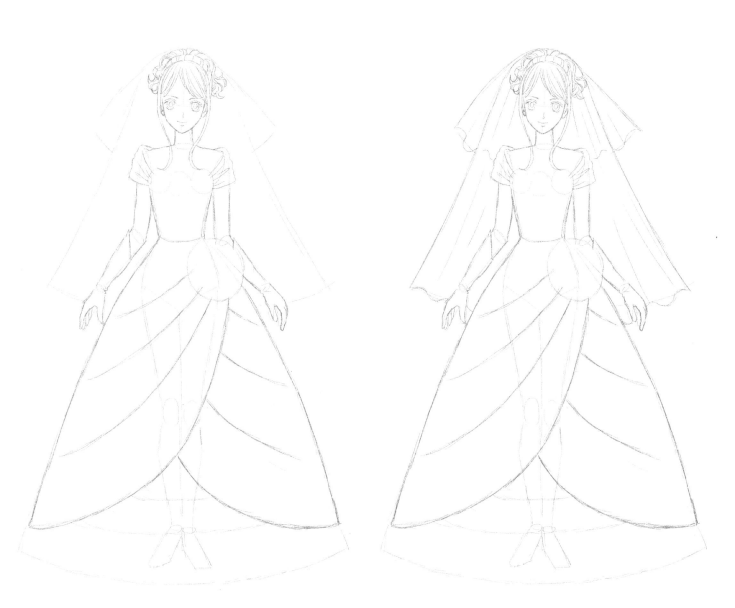

11. Start to turn the circle into a rose. Like with the Gothic character, begin the rose with this design so that it looks a little like an eye.

12. Draw a circle around what you've started with the rose.

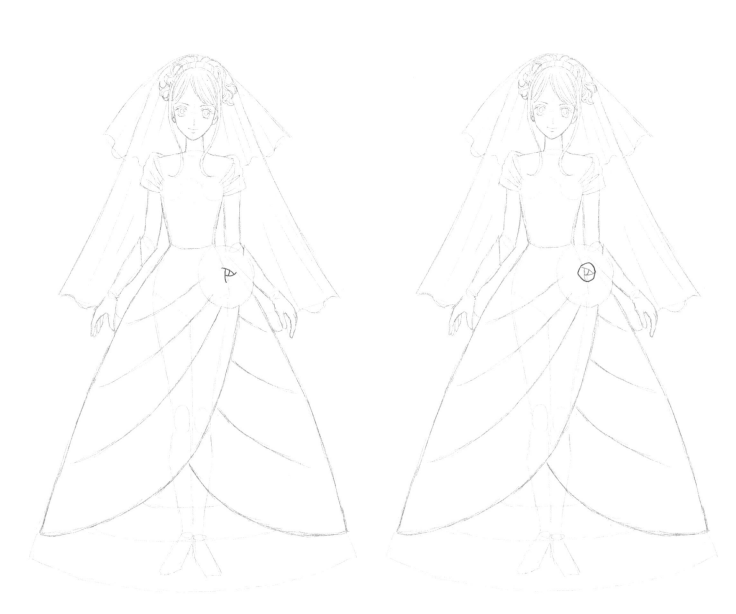

13. Continue the pattern, increasing the petals as you go out.

14. The outer petals will also grow increasingly bigger than the inner petals.

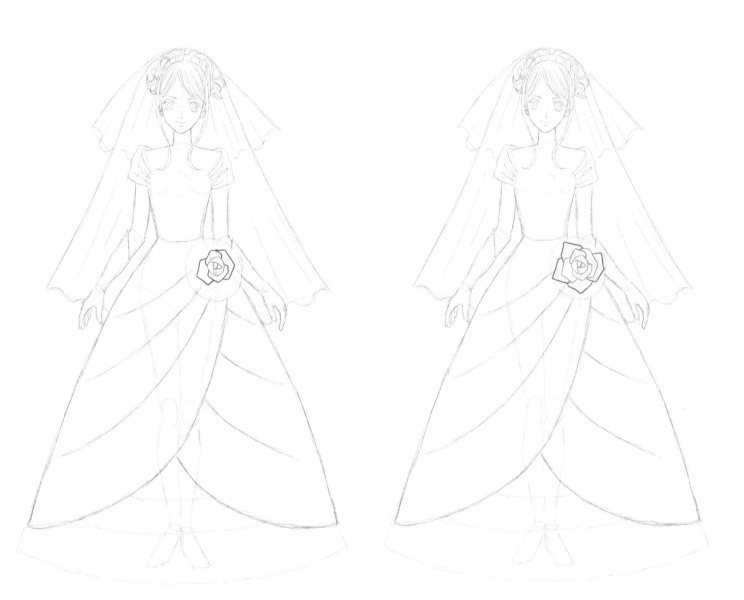

15. Loop more petals around the previous ones, filling out the circle.

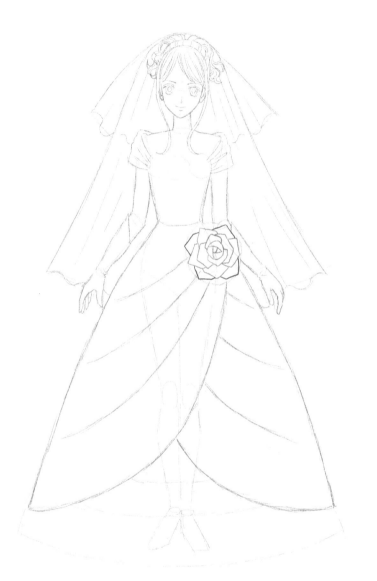

16. You're almost there! Do the last few petals to finish out the circle.

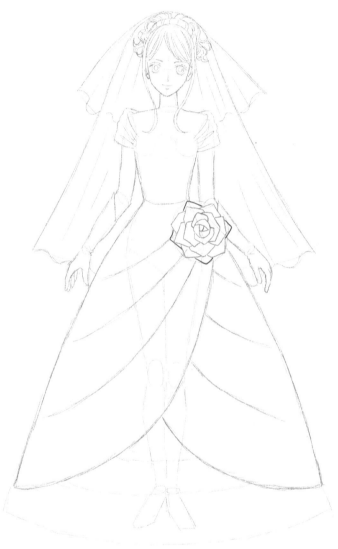

17. Put smaller roses along the top of her dress. Use the same pattern as you did with the bigger rose, though you can change the shape of the petals.

18. Draw the frill along the blue line, making it wavy and a little random.

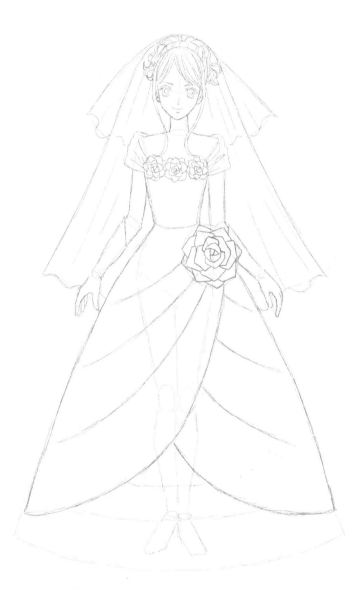

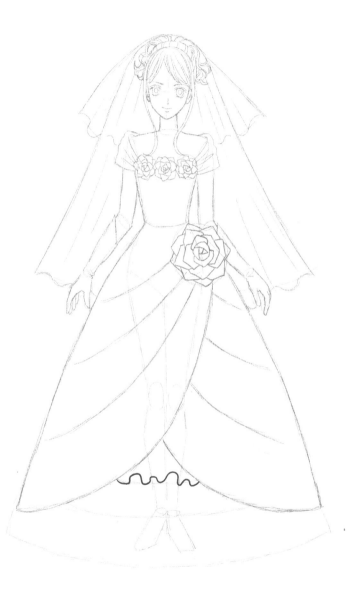

19. Go back to the waves you just made and put lines on each side of them, giving her dress a three-dimensional look.

20. You can see the effect here of what it does for the frills.

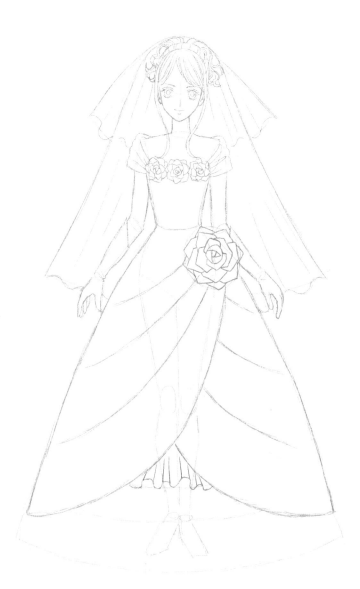

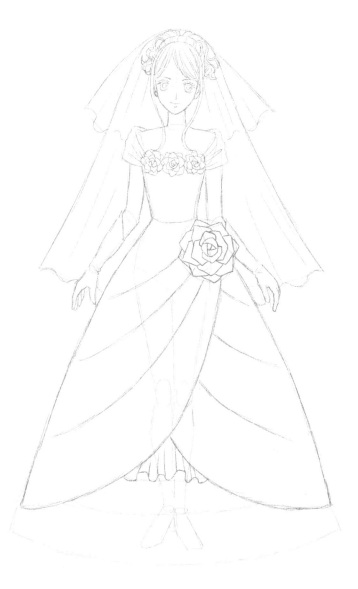

21. Continue the same pattern and add more frills to the bottom of her dress.

22. Adding more layers of frills really makes her dress look fancy, and it just takes doing the same pattern.

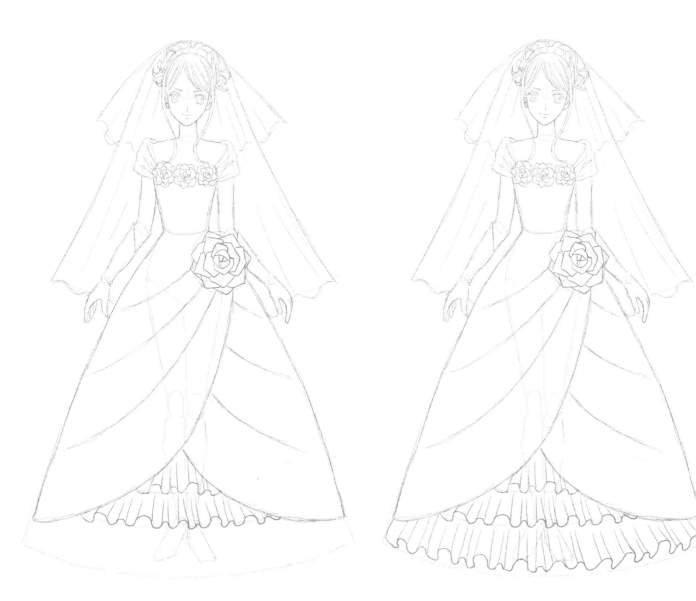

23. Sometimes the inside of the frill can be seen, so make sure to draw in little lines for that.

24. Begin the inking process using a delicate pen to go over the facial features.

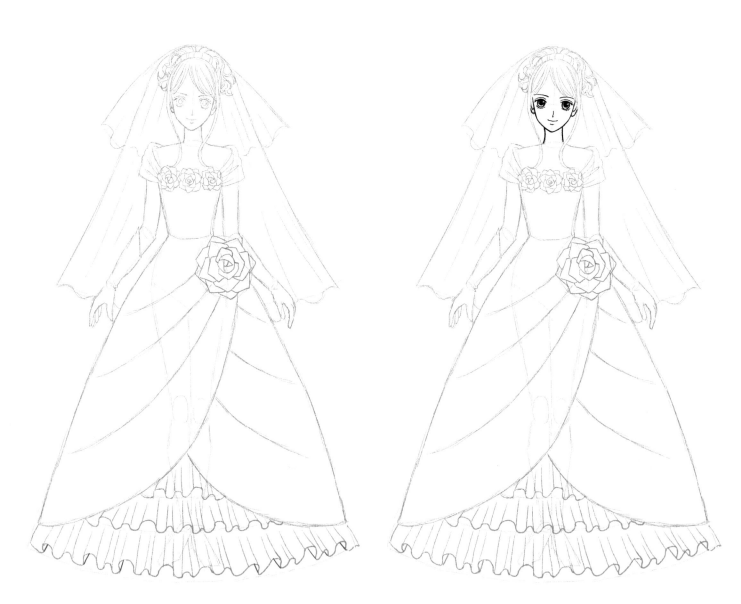

25. Start inking her hair. For curved lines like these, it will look best if you can draw it in one stroke. Otherwise it can look choppy. It's recommended you practice this elsewhere first so it becomes easier. If the inking lines are slightly off the pencil lines, you can still make that work. Turning the paper at different angles will also help you create her hair in single strokes.

26. Ink the rest of her hair, also being careful with your lines.

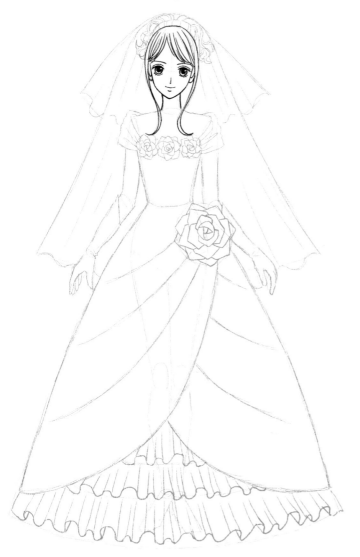

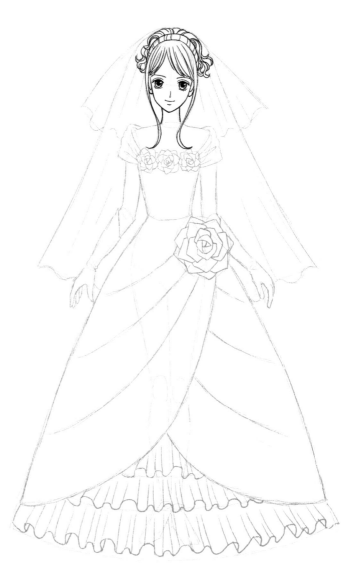

27. Ink the veil. Use a very delicate pen so the veil will also have a delicate look.

28. Ink the roses. If they were already neatly drawn during the sketching part, that makes inking them much easier.

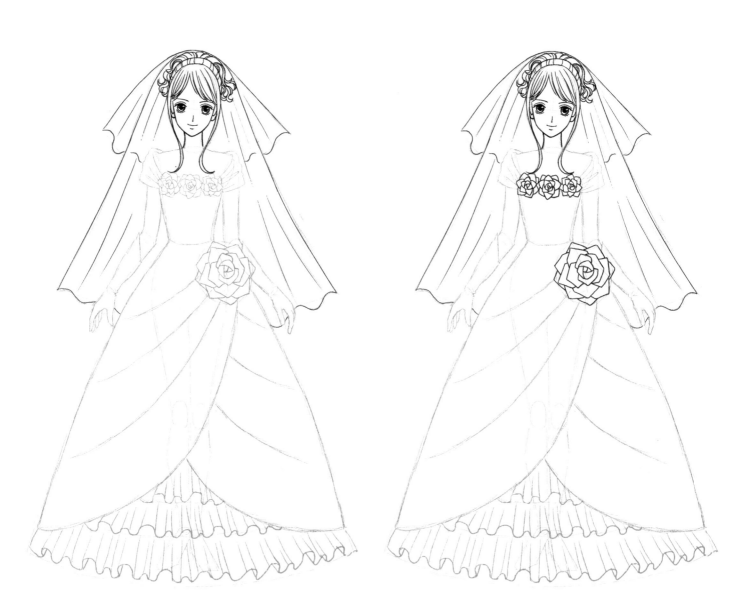

29. Start inking her dress.

30. Ink her arms and her gloves. Be sure to get the creases at her wrists.

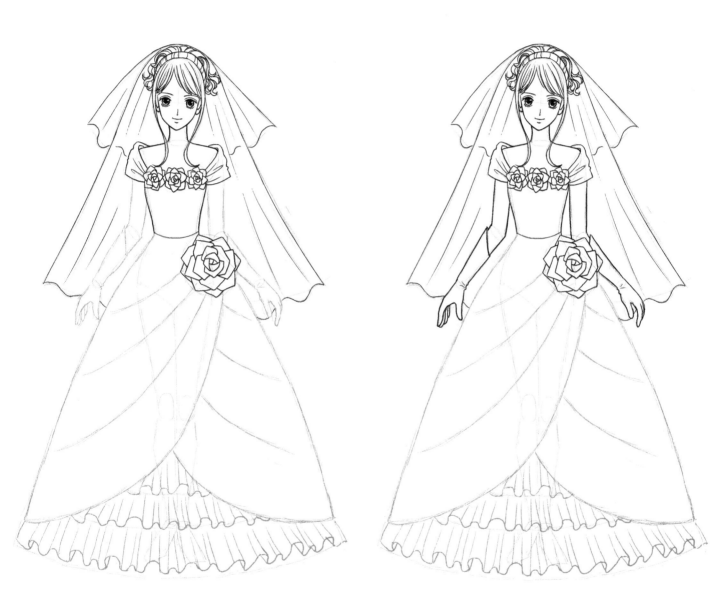

31. Like her hair, it will take a careful finesse to ink the graceful curves of her dress. Try practicing elsewhere first so the ink lines come out smoothly.

32. Finish inking her dress. The frills should be done with a pen that gives off delicate, thin ink.

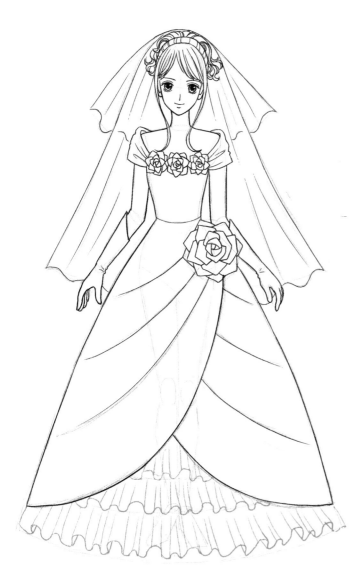
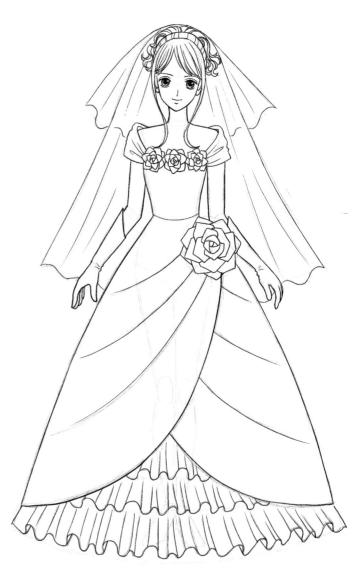

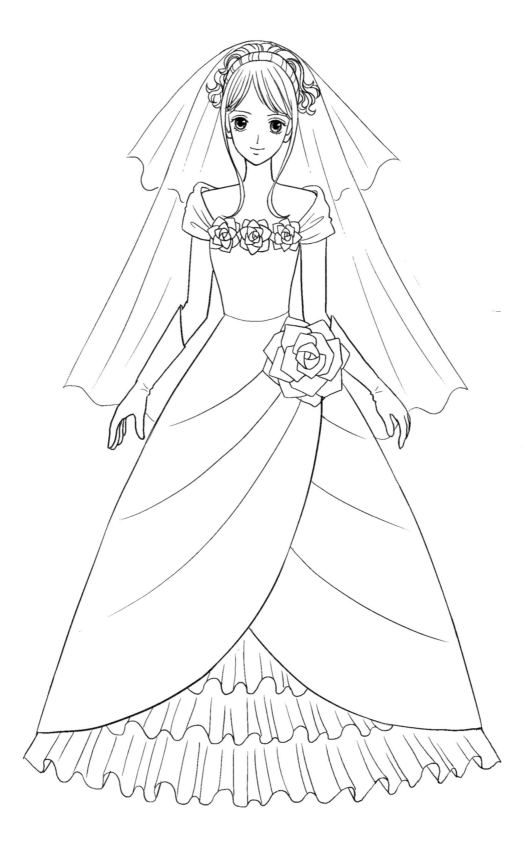

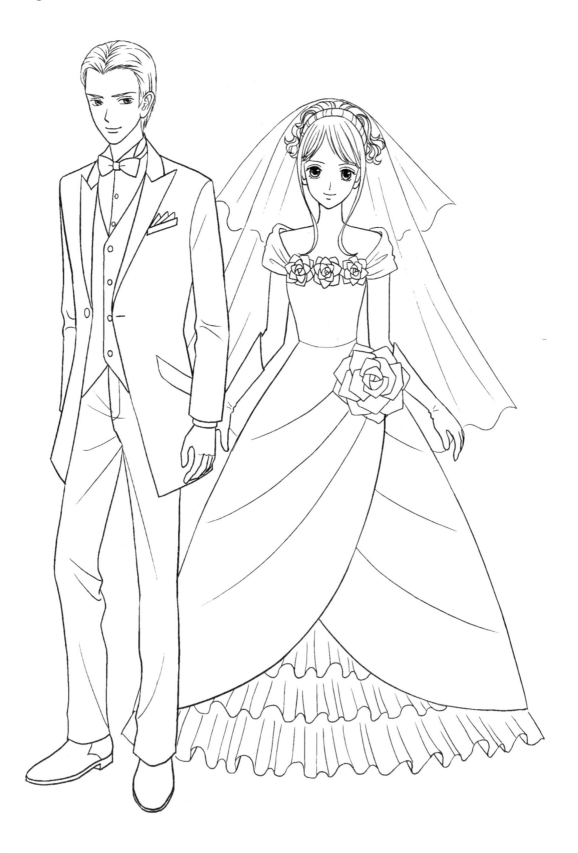

Businessman

Plenty of manga have plots with fantastical characters and faraway places, but many manga also have realistic storylines about what everyday life is like in Japan. Many Japanese men work in business, which leads to the popularity of the businessman character, who is well-dressed in a suit. What happens to him in manga, though, can be realistic or wherever your imagination takes you!

1. Draw a basic outline of the businessman. The rectangle to his side will become his briefcase.

2. Draw the start of his face.

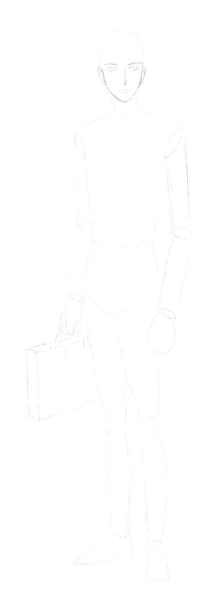

3. Draw his hair. Notice how his hair flows away from the part.

4. Start on his collar and tie.

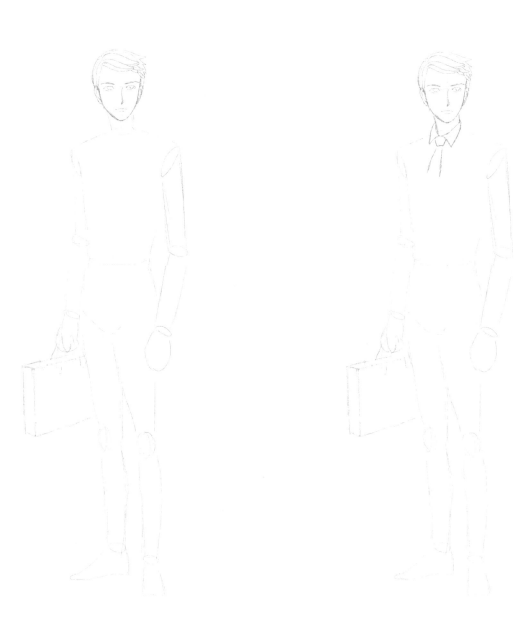

5. Continue on his suit jacket. Below his tie, the jacket will be at a curve the way it's buttoned up.

6. Finish his coat. Note the pockets and the creases by his shoulders and elbows. He also has little cuffs just underneath his jacket sleeves.

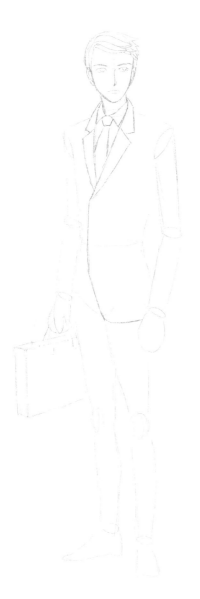

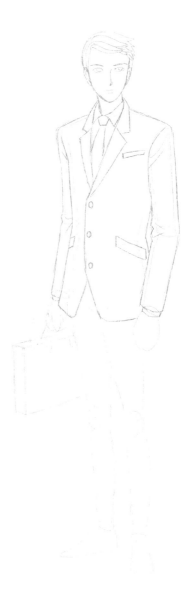

7. Draw his hands. His one hand will be curled around the briefcase handle, and the other one will be curled up so you can barely see his fingers. Just a few bumps will show where his fingers are.

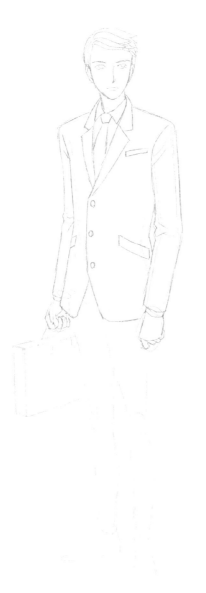

8. Draw his pants. His pants are a little loose, but they have vertical lines going down the front because they are pressed.

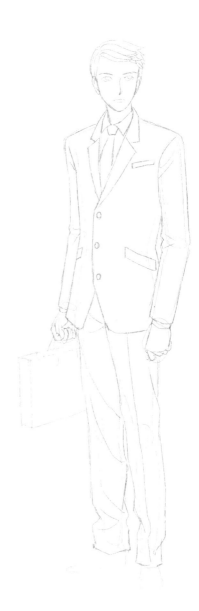

9. Draw in his dress shoes. The shoes will have little heels and lines going over the tops.

10. A ruler will help you get straight lines as you draw the details of his briefcase.

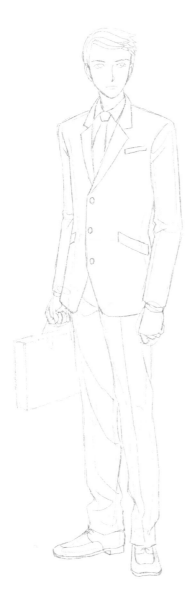

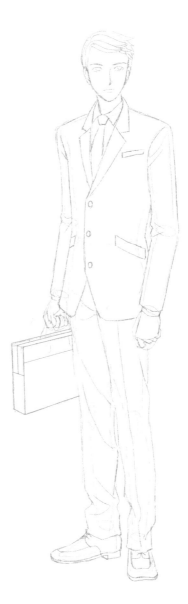

11. Make the upper corner of the briefcase round and then add in the handles. Drawing the briefcase out very neatly now will make inking easier later on.

12. Begin the inking process with his face. Use a pen with a delicate nib for his facial features.

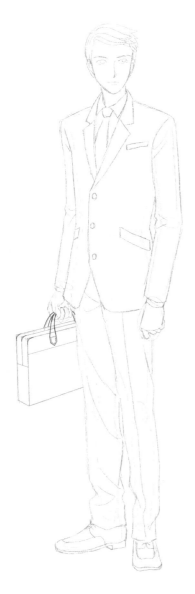

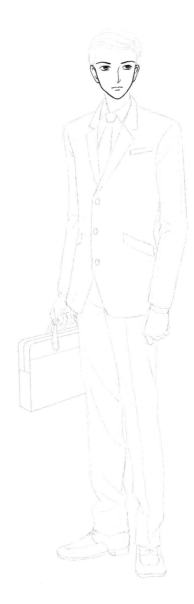

13. Ink his hair.

14. Ink his collar and tie. Use a pen with thicker ink than you used for his face.

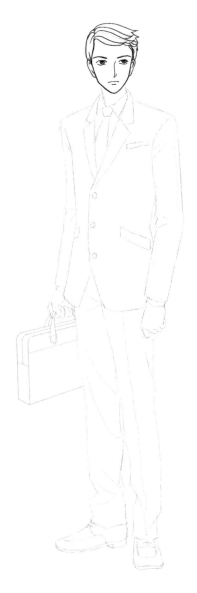

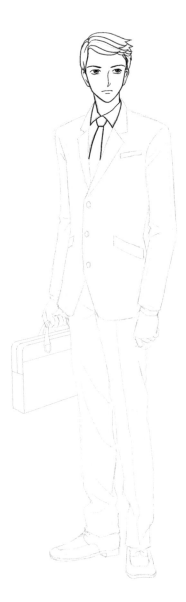

15. Finish inking his coat. Use a finer pen for the creases in his clothing.

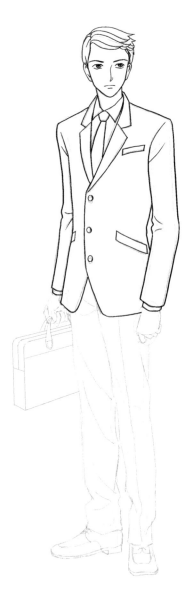

16. Ink his hands, going carefully over the fingers and knuckles.

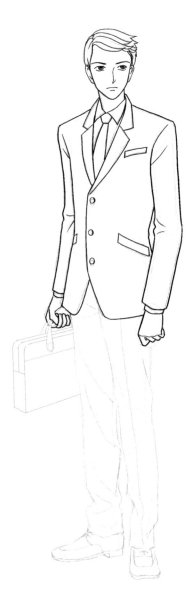

17. Ink his pants. Use a thicker pen for the outline of his pants and a finer pen for the creases and lines on the inside.

18. After his whole body has been inked, ink the briefcase.

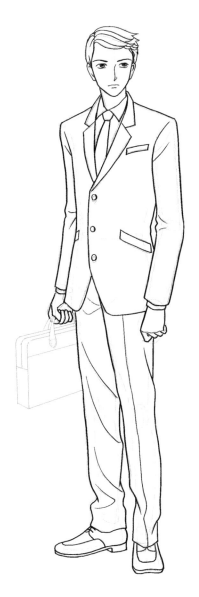

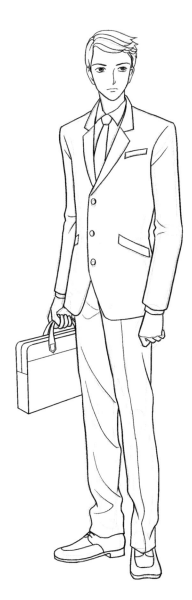

19. After erasing the original pencil lines, you can color his hair in black. A pointed, thin brush pen works well for this. Paint his hair as shown on page 11, leaving white parts. Then paint the tie and part of the briefcase. You can also add more colors and screentones, as many businessmen wear gray suits.

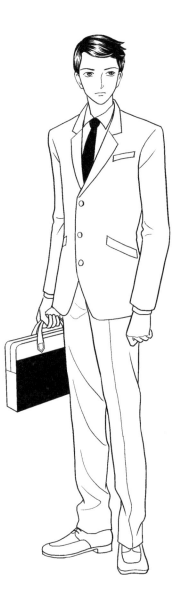

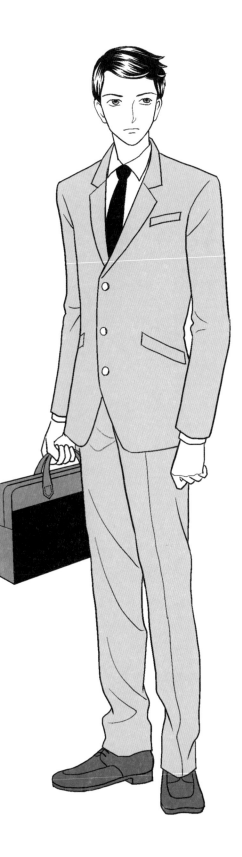

Nekojin

Nekojin refers to cat people, or people with anthropomorphized cat characteristics. Some manga, like *Loveless*, have *nekojin* as main characters, but it's also common for popular manga characters to be drawn in a *nekojin* style for fun, whether it's in fanart or a panel in the comic. *Nekojin* are usually cute characters shown with cat ears and a cat tail.

1. Draw the outline, including a line for the cat tail. This character has a playful stance and is lifting his hands in a pawlike way.

2. Start to draw the face. Notice the happy, playful mouth and the larger than average eyes.

3. Draw the spiky hair and cat ears. The ears will be a little jagged along the edges to look like fur.

4. Draw the hands. These are a little tricky because of the angle. But you can make the fingers curl in by drawing a few bumps of different lengths.

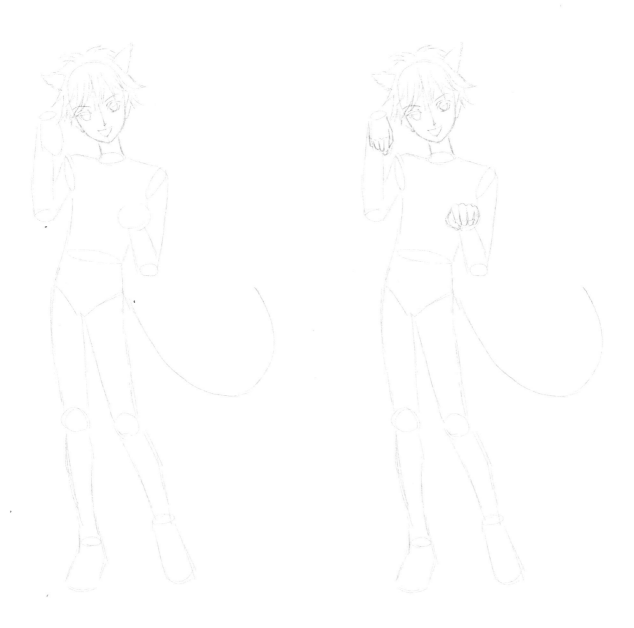

5. Draw his coat. It will have some flow to it and not hang down straight.

6. Draw his shorts and shirt. Put creases in the clothes.

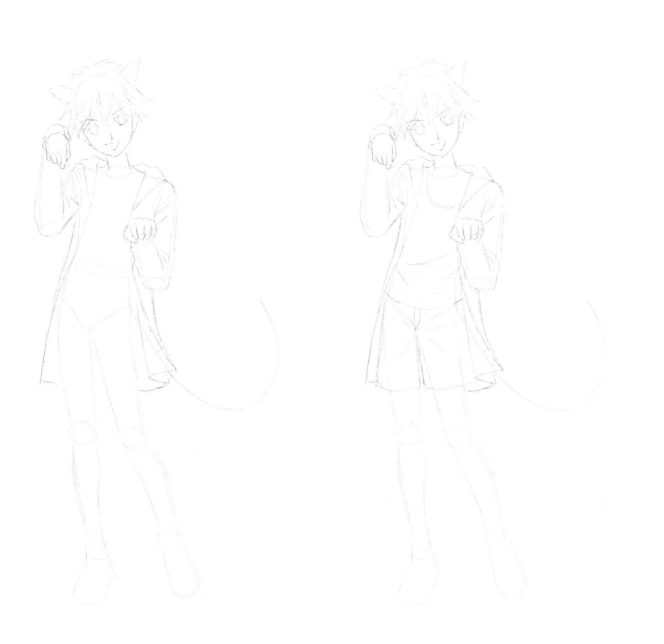

7. Finish drawing his tail.

8. Draw his legs and start on his tennis shoes.

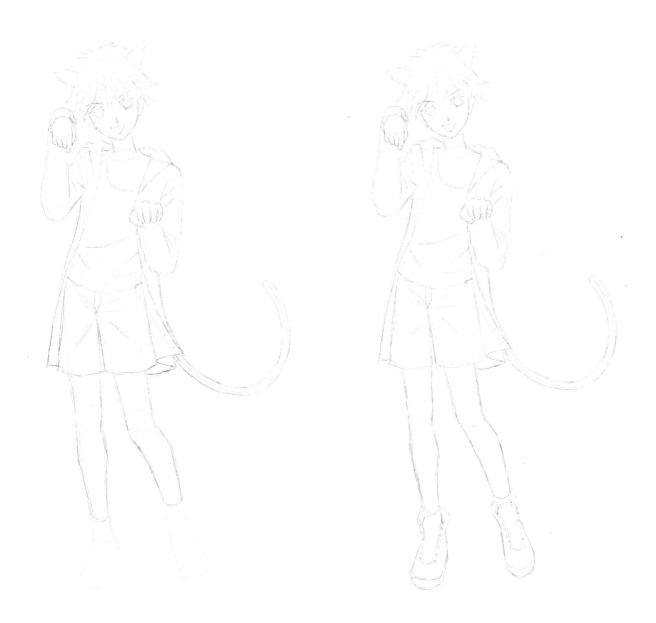

9. Shoelaces are a common sight, but they can be a bit of a challenge to draw and make them look right. If you draw the strings very neatly at the detailed sketching phase, it makes inking on them much easier.

10. Look how the strings overlap. We're going to continue this pattern.

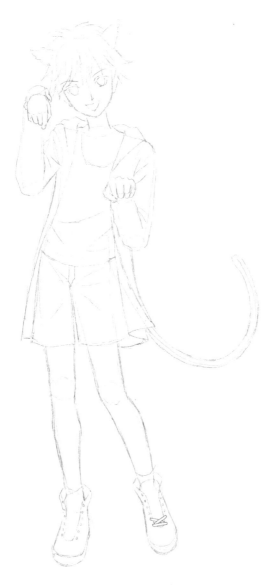

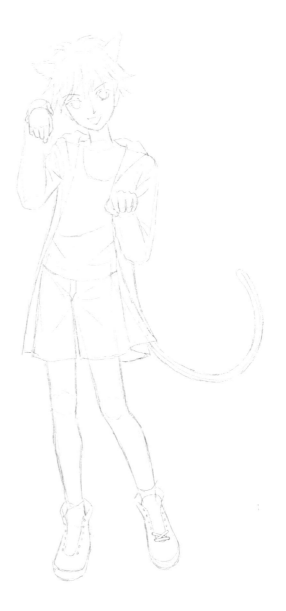

11. Draw two more strings.

12. See how the pattern continues. Don't worry if you still have trouble drawing the laces. Many art students have difficulty with them.

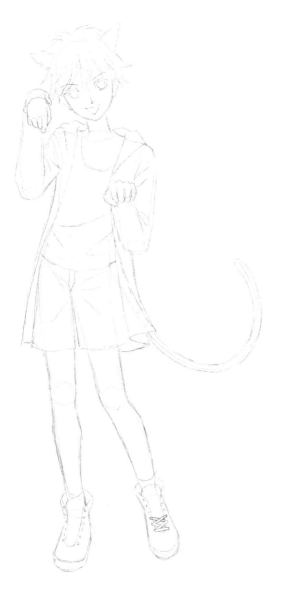

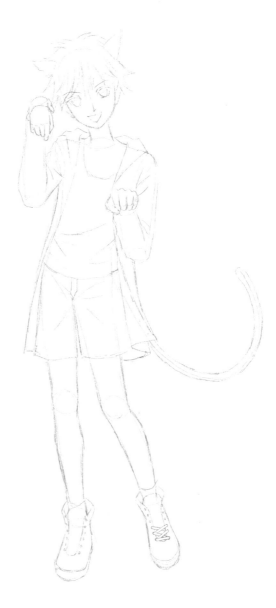

13. The strings will continue to go up his foot, overlapping.

14. Watch how the pattern is making the lacing look real.

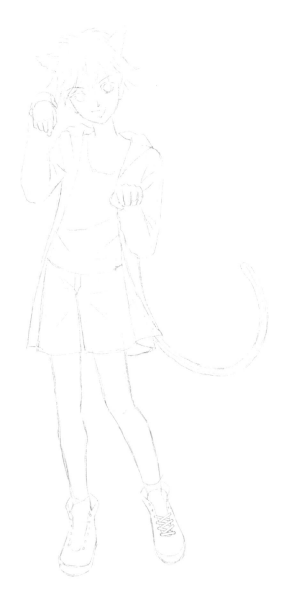

15. Continue with the pattern.

16. Keep working on the laces.

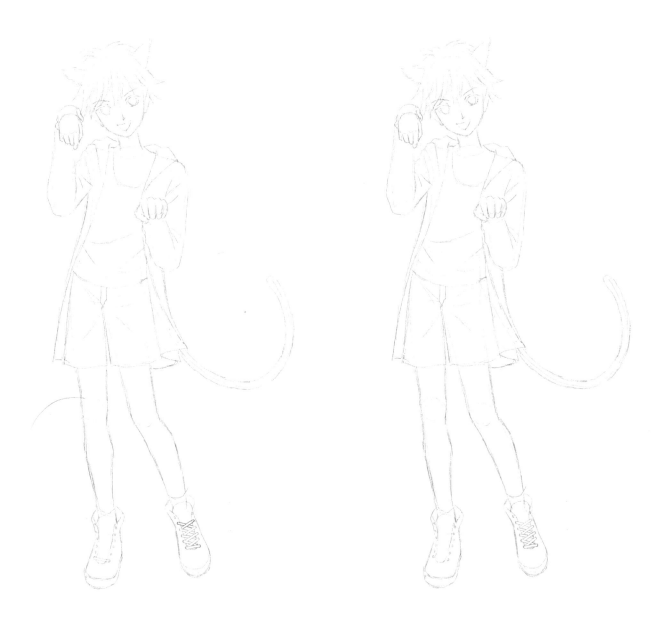

17. We're almost done! Now that the strings are higher on his foot, they're going to be longer and stretch more over his shoe.

18. Take a look at how it's coming together.

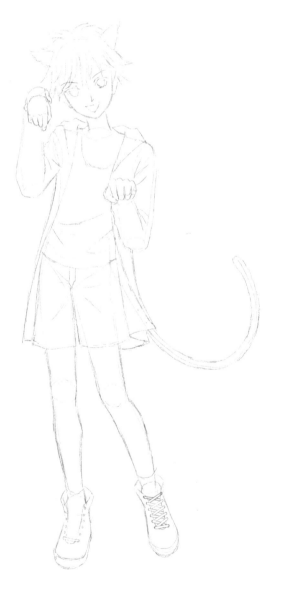

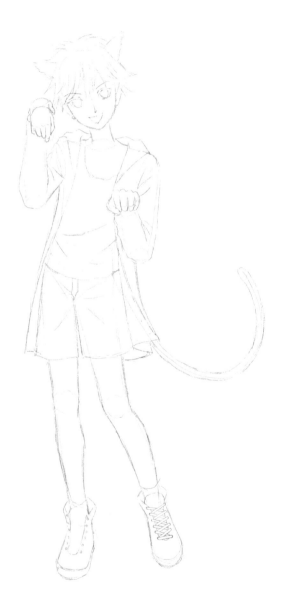

19. Now it's time for the knot at the top of the strings. There are two loops, a small middle circle for the knot, and two more strings hanging down.

20. You can see the final result for his left shoe.

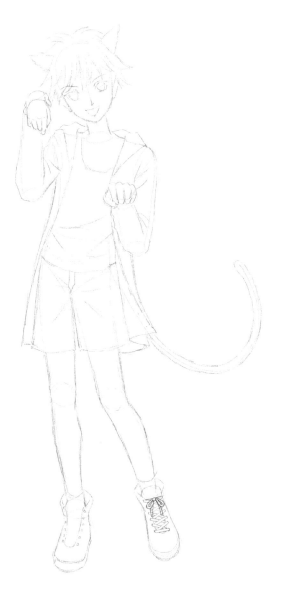

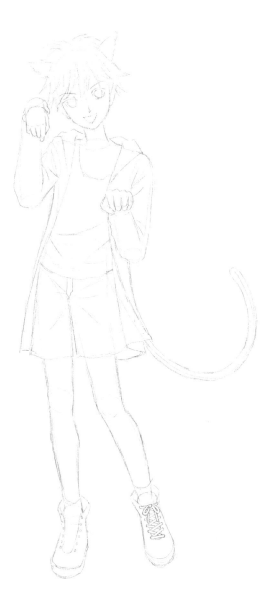

21. Draw the laces on the other shoe in the same way. Be careful to make sure it's mirrored so they look the same.

22. Once he's all drawn, it's time for the inking. Use a delicate pen for inking his facial features.

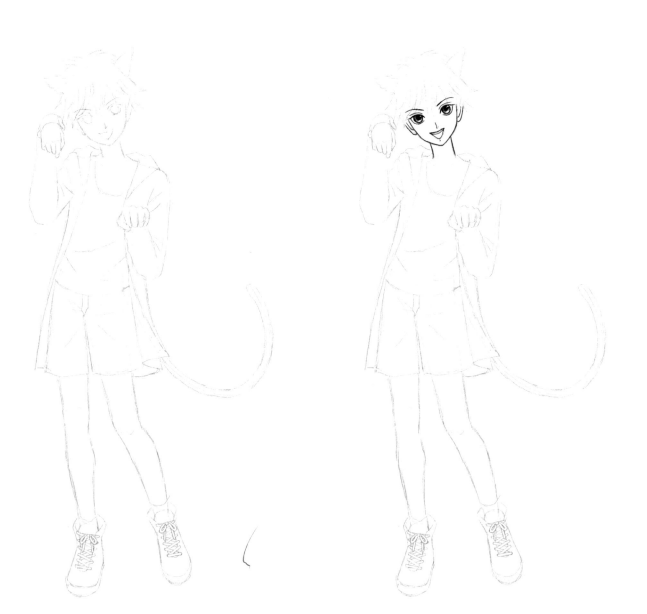

23. Ink his hair. You can add additional lines according to your taste.

24. Ink his hands and the jagged lines for his knuckles.

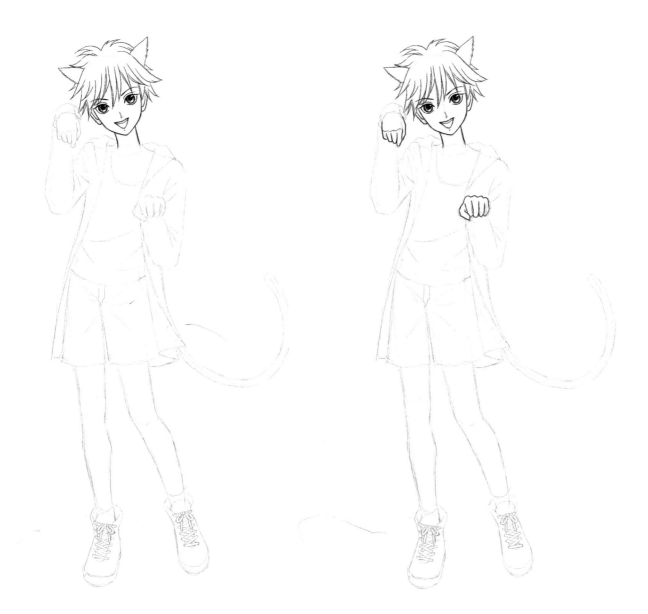

25. Ink his coat, using a thicker pen than you used for his face.

26. Ink his shorts and shirt. Use a thicker pen for the outside of his shorts and a more delicate pen for the creases.

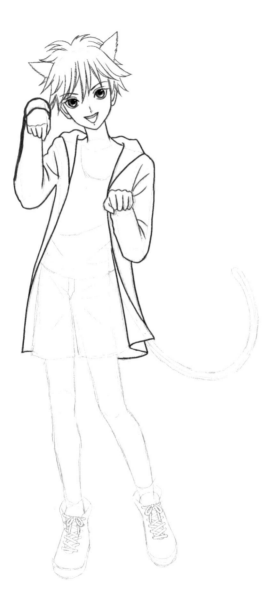

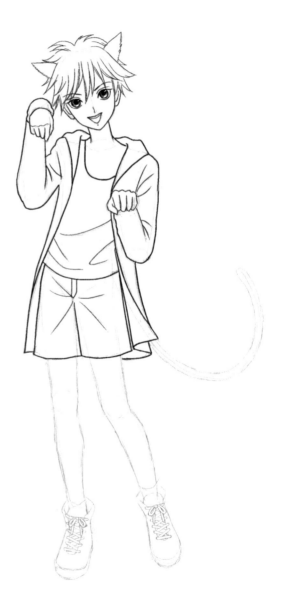

27. Ink his legs, tail, and socks.

28. Ink his shoes. Be careful going over the laces. After that, you can erase the pencil lines and color (or not color) him as you wish.

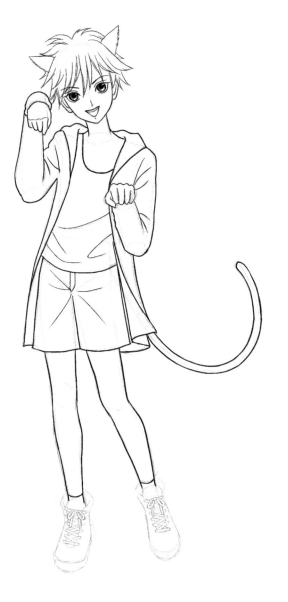

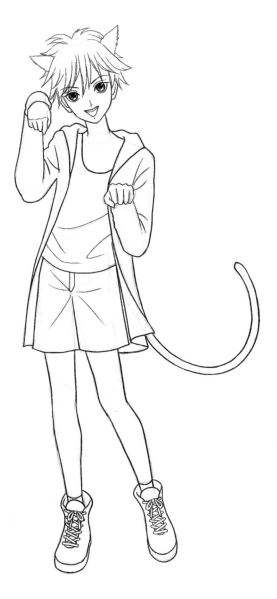

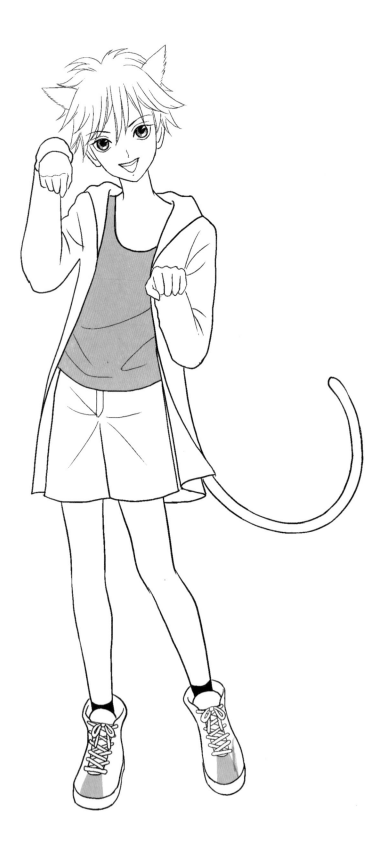

Shonen Hero

The book started with a typical looking heroine for a shojo manga, so now we're going to look at a typical looking hero for a *shonen* manga, or a manga aimed for boys. Often these are young men who are ambitious, opinionated, and strong, and they have a penchant for spiky hair. (Think of everyone from Naruto to Goku.)

1. Start with the outline. His legs and arms are out in a tough stance, and it's a view from overhead.

2. Draw his face. He's winking and has a cheeky grin. One eye will be shut, and all you have to do is draw a curve for that. His open eye will be larger than average, to show his boyish personality.

3. Draw his spiky hair. In *shonen* manga, it's okay to make hair that defies gravity, but keep in mind if you're working on a manga, you'll have to draw spiky hair from different angles. You can experiment with the thickness and direction of his spiky hair.

4. Draw his necklace and a little ring-shape at the end.

5. Finish his necklace with what looks like an upside-down, curved teardrop.

6. Begin drawing his shirt. He has a square shaped collar and his shirt will fold left over right in front of him.

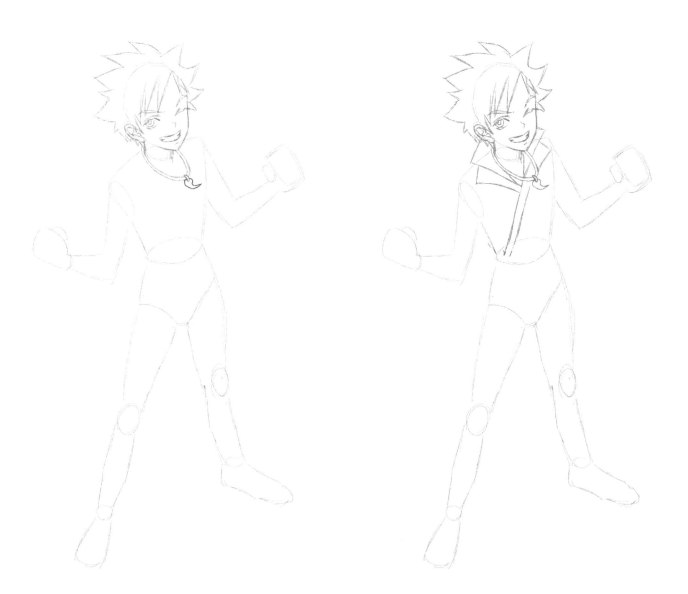

7. Draw his belt and buckle.

8. Draw his arms and fists. Be conscious of his muscles. A *shonen* hero can be anything from vaguely muscular to bulky with muscles, like in the *Dragon Ball* franchise.

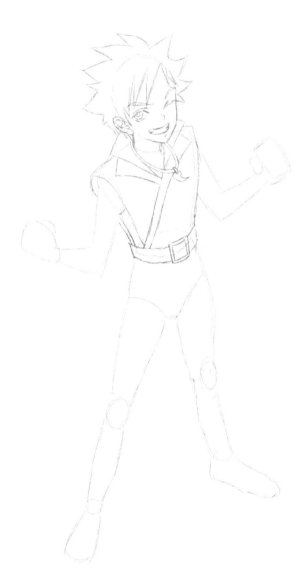

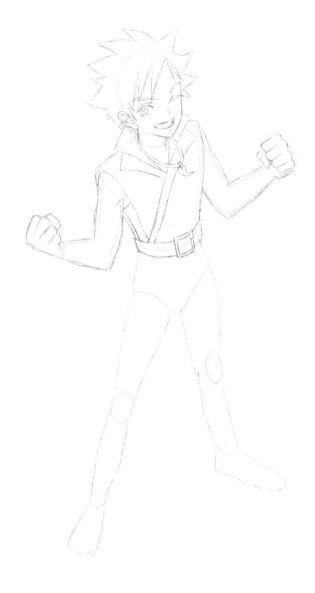

9. Keep drawing his clothing. Continue his shirt below his belt.

10. Draw his pants, putting creases at the knees.

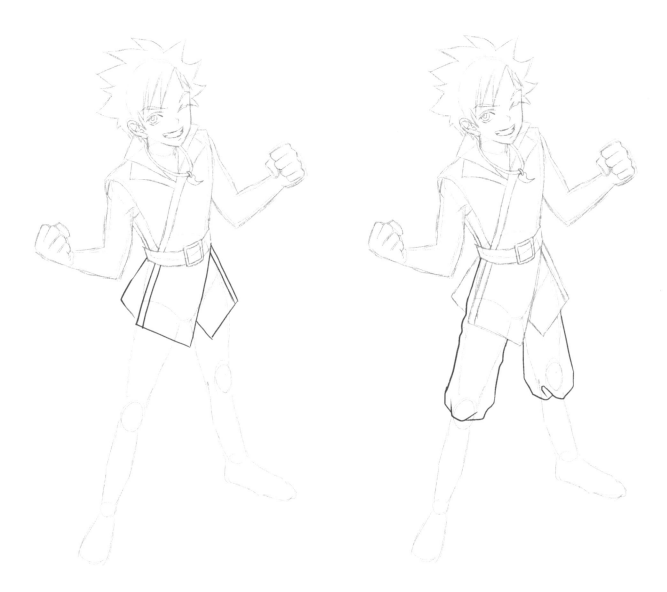

11. Below his pants, begin drawing his boots.

12. Draw the bottom of his boots, matching the angle of his feet.

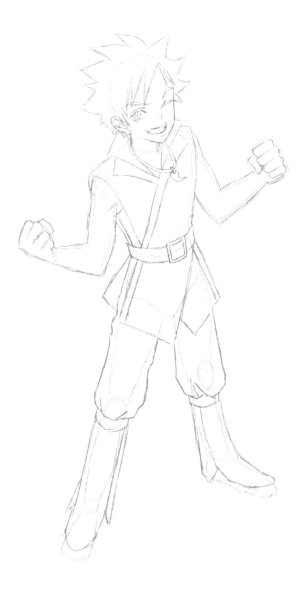

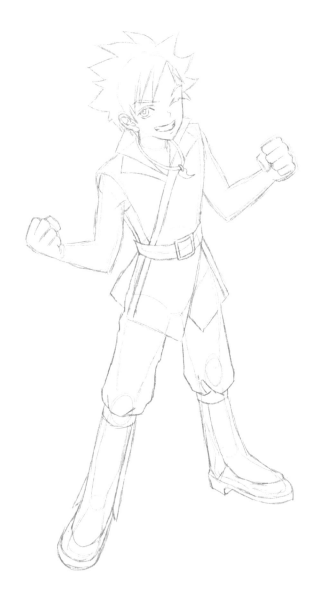

13. When you ink, use thicker lines than usual for faces. The thicker lines make *shonen* characters look more tough.

14. You can ink his hair while arranging the shape.

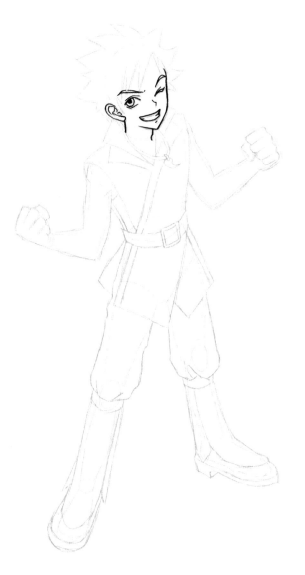

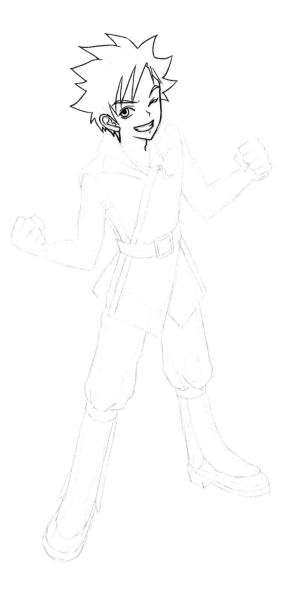

15. Keep inking his clothing, sticking with thicker ink for boldness.

16. Ink his arms and hands, going carefully over the lines of his fingers.

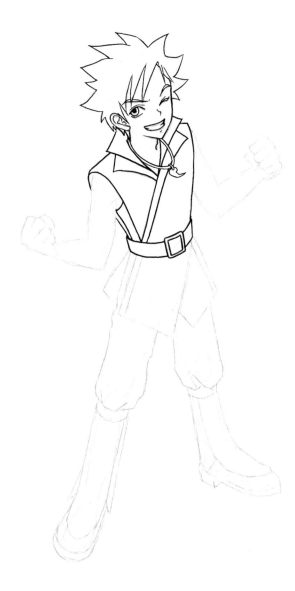

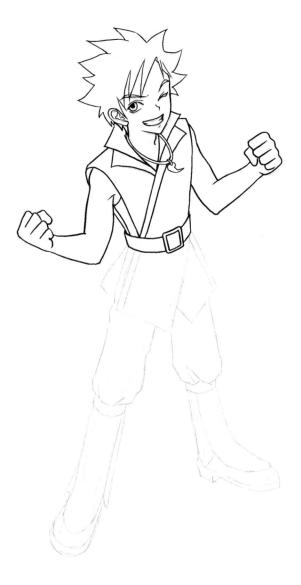

17. Finish inking his clothes.

18. Ink the boots. After the inking is done, erase the pencil lines and you can color the belt black and put some screentones on his clothes if you like.

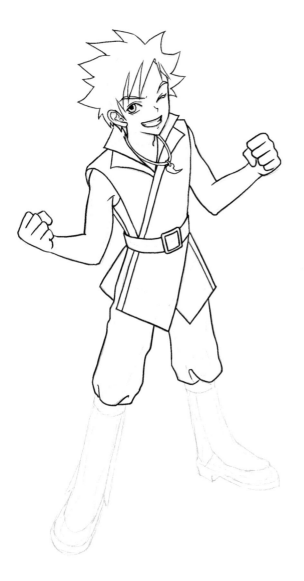

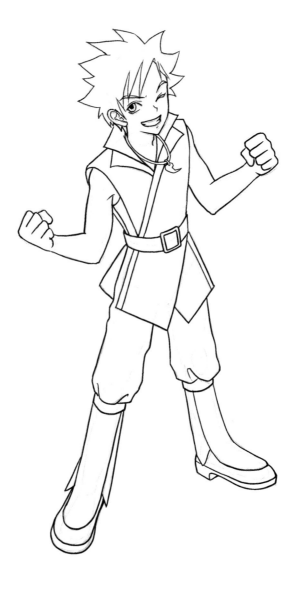

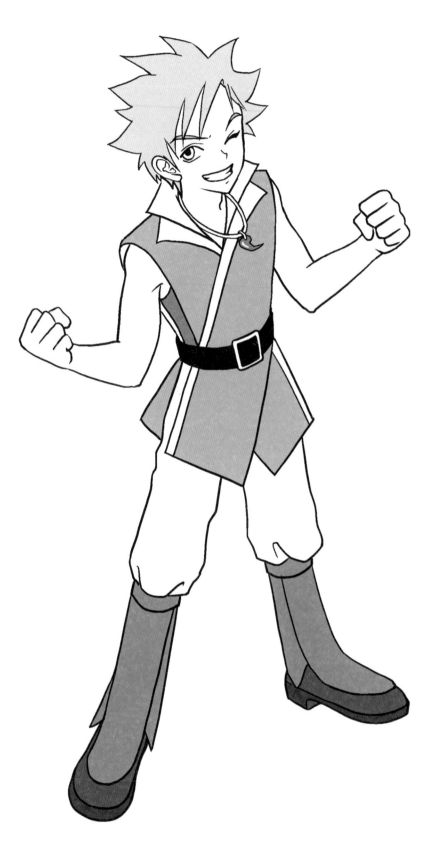

Gag Manga

Gag manga is a type of comedic manga where characters tend to be absurd, over-the-top, and silly. To fit with this style of humor, characters have exaggerated features. Sometimes in gag manga the characters always have these features, and sometimes they just look absurd in certain panels to show characters respond to an absurd situation.

1. Start with the outline. The strange way he's standing is part of the absurdity of his character.

2. Draw his face. Eyes and mouths are very important at showing personality, so exaggerated mouths and large eyes are good for gag manga.

109

3. Draw sprigs of his hair. They should all begin where his hair is parted.

4. Because of his awkward stance, his tie will be flapping. Unlike a businessman, the tie is also not tight around his neck. This gives him more of a sloppy, silly look.

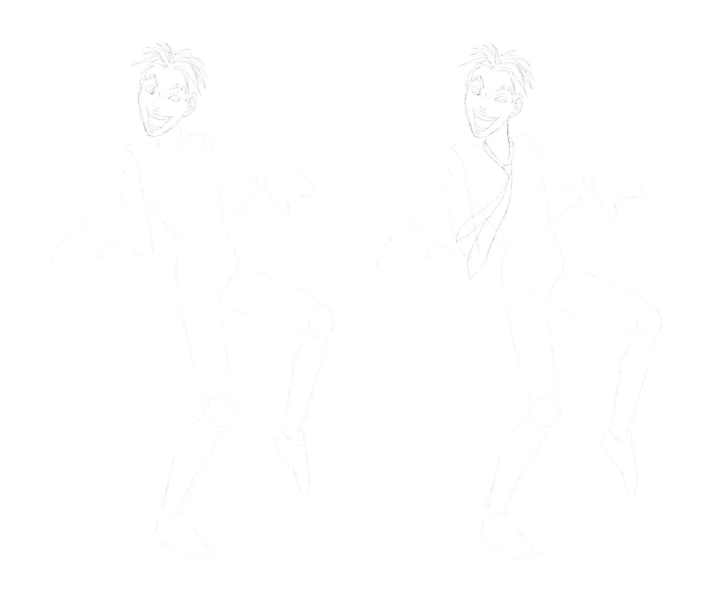

5. Draw his shirt, giving it creases on the sleeve and over his belly.

6. Draw his arms and hands. The splayed fingers also help with the mood being established for this character.

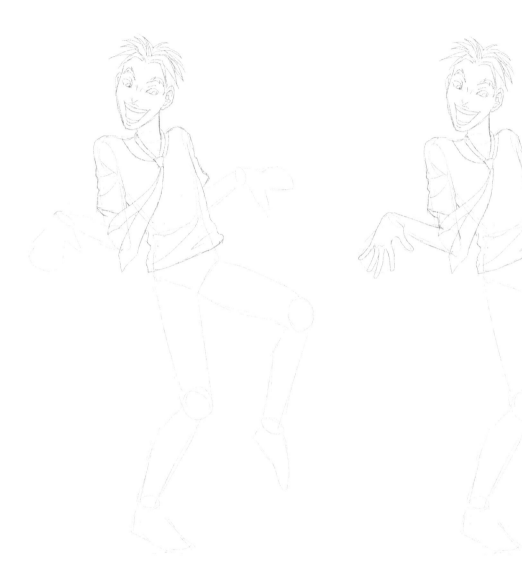

7. Draw his pants, making sure to give it the proper creases.

8. Complete his outfit by drawing in his shoes.

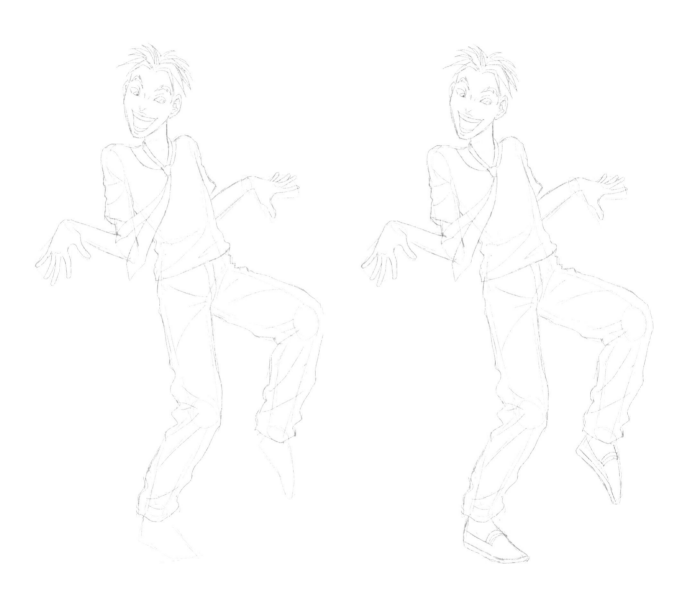

9. Begin inking, going carefully over the features of his face.

10. Go over the spikes of his hair.

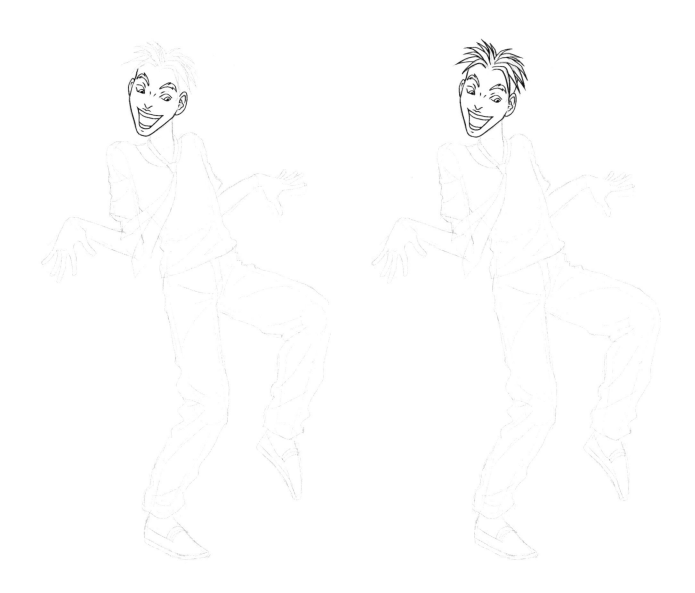

11. Ink his tie.

12. Ink his shirt. Use a thinner pen for the creases inside his shirt.

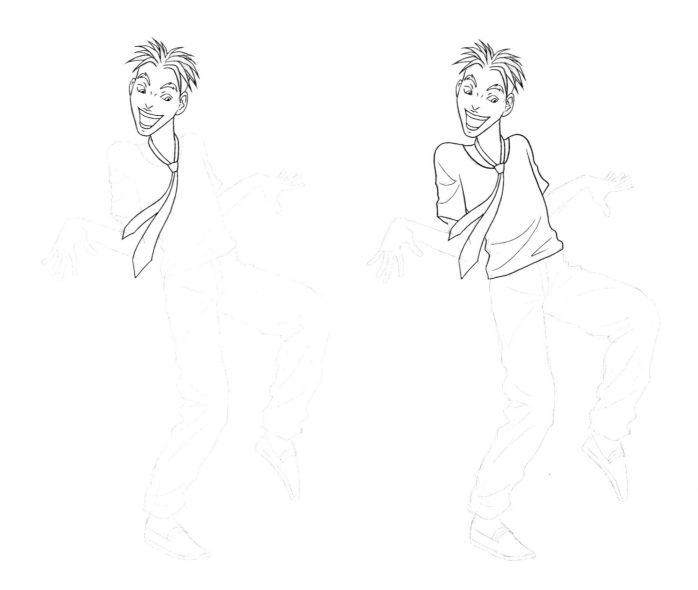

13. Ink his hands.

14. Ink his pants. Use a thinner pen for the creases.

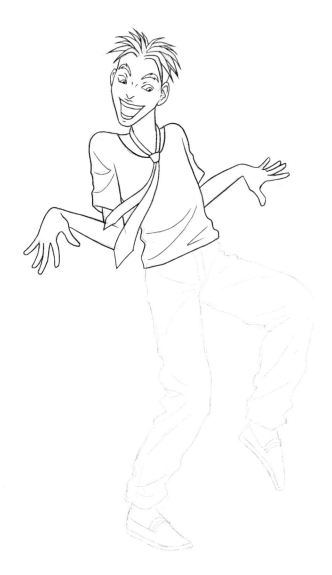

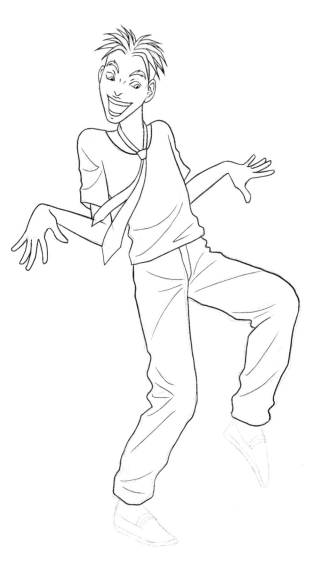

15. Finish by inking his shoes.

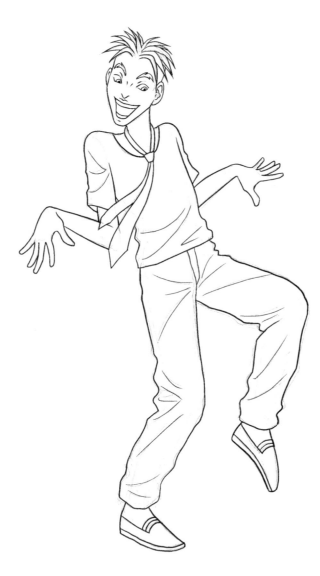

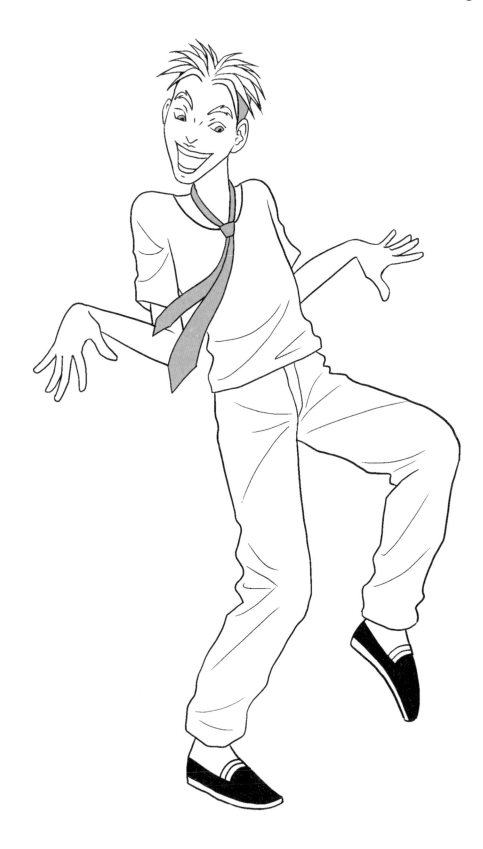

Seme

Boys Love, or BL, is a popular manga genre for girls that explores relationships between men. Traditionally the two men fall into one of two categories: *seme* or *uke*. A *seme* is a more aggressive, masculine character, typically drawn taller than the *uke*, and with broader shoulders and smaller eyes. His attitude is usually confident and strong, as shown in this *seme* image.

1. Draw the outline. A *seme* character will be fit and have a strong stance.

2. Draw his face. He will have attractive features and small eyes.

3. Characters in Boys Love, whether *seme* or *uke* (or a character who doesn't fall into this characterization), will have stylish, neat hair. When you draw the hair, be conscious of the stream of the hair. It starts from the part.

4. Draw his shirt, giving him buttons down the middle. If you want to give him another outfit, keep in mind it should be neat and form-fitting, not slovenly. Having the shirt slightly unbuttoned at the top also adds to the character's effect.

5. Over his button-down shirt, draw in a nice jacket with the collar turned up.

6. Draw his hands, which will be supple and long-fingered.

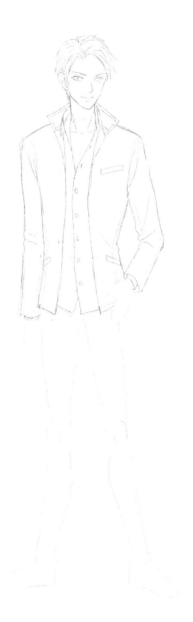

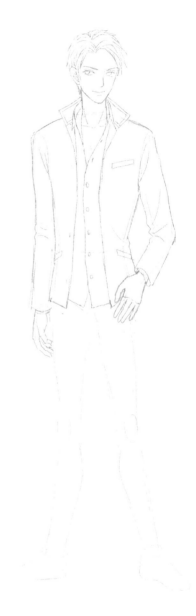

7. His pants are form-fitting and slightly creased.

8. A *seme* character's shoes will be smooth and stylish. He probably wouldn't wear something easygoing or ordinary like tennis shoes.

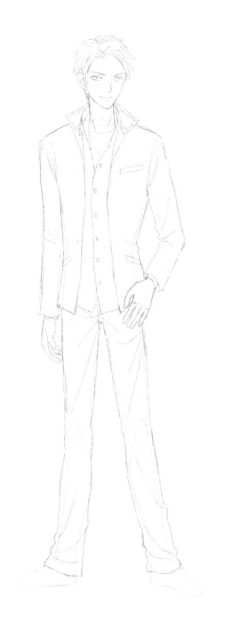

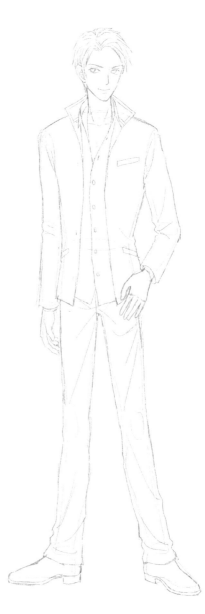

9. Ink his face, using a finer pen to go over the delicate facial features.

10. Ink his hair and start on his shirt. Use a thin-tipped pen for the fine lines on his throat and chest.

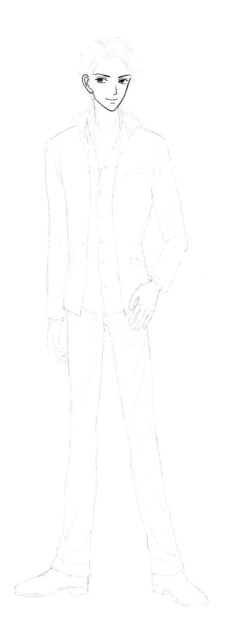

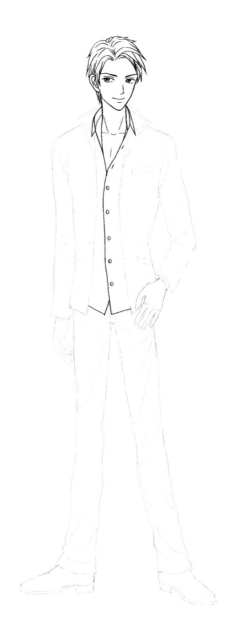

11. Ink his jacket, including the creases.

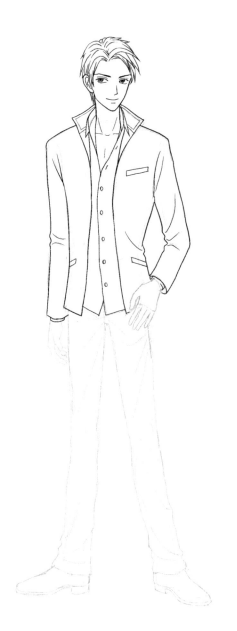

12. Ink his hands, using a finer-tipped pen for the knuckles.

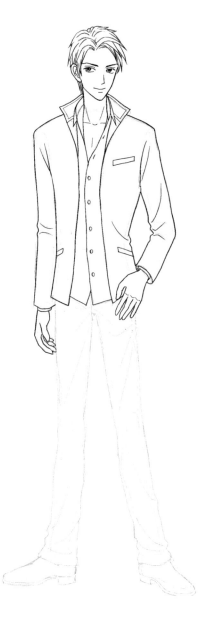

13. Ink the rest of his clothes and his shoes. Use a finer-tipped pen for the creases.

14. You can fill in his shirt and shoes with a brush pen. Draw a white line along the black shoes.

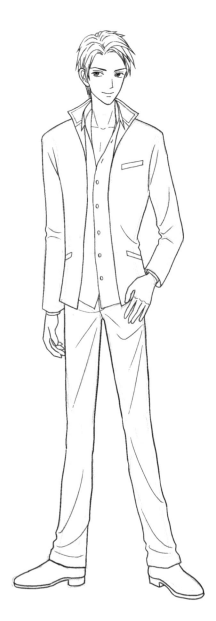

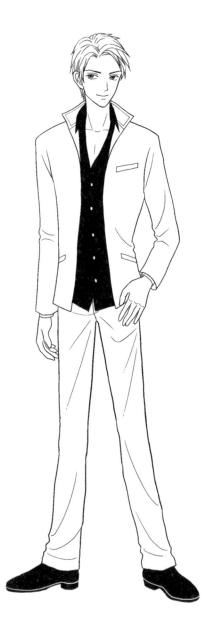

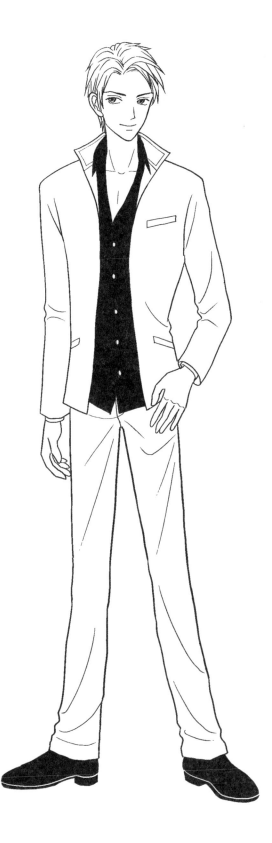

Uke

Traditionally, the counterpart for the *seme* in BL is the *uke* character. This character is typically shorter, with a willowy body shape and a more effeminate appearance. He is usually more timid and fragile than the *seme* character.

1. Draw the outline. His shoulders are smaller than the *seme*'s shoulders, and the way his hand is drawn up to his chest makes him seem more delicate and timid.

2. Draw his face. The *uke*'s eyes will be larger and rounder than the *seme*'s eyes.

3. Draw his hair, which will be soft and well-combed. Male characters in BL do not have the spiky hair seen in *shonen* manga.

4. Collars are attached over the original collar in his shirt.

> Collars are attached at their foundations like the reference pictures below. Draw the foundation first.

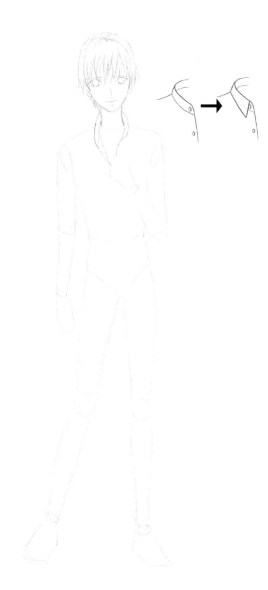

5. Finish drawing in his long collar.

6. Draw his shirt. Like the *seme*, it's a buttoned-up dress shirt, and it doesn't have to be fully buttoned.

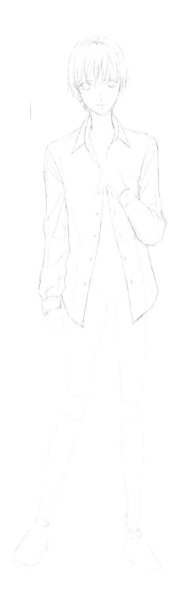

7. Draw his hands, which will be smaller and more delicate than the *seme* character's hands.

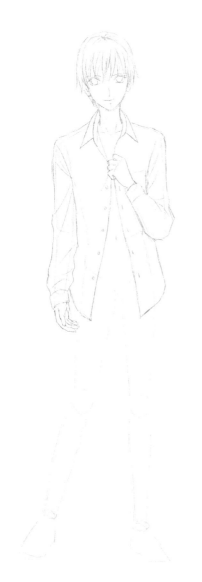

8. His pants will be form-fitting and slightly creased.

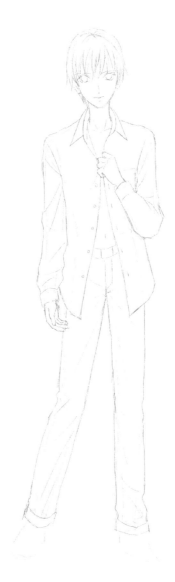

9. Draw his shoes. Like the *seme* character, he'd be wearing nice shoes. These are loafers that look as if they could be worn to school.

10. Begin the inking with his face, using a thinner pen for the delicate facial features.

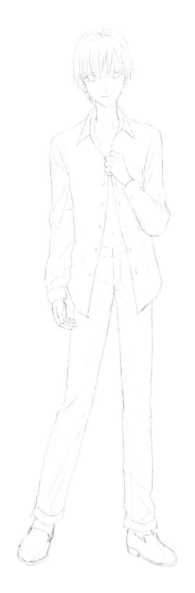

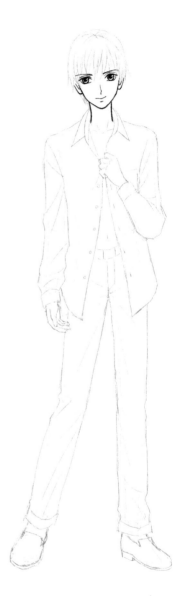

11. Use a very fine-tipped pen for his soft hair.

12. Use a fine-tipped pen for his clavicle. A thicker-tipped ink pen works for his hands and the outline of his shirt.

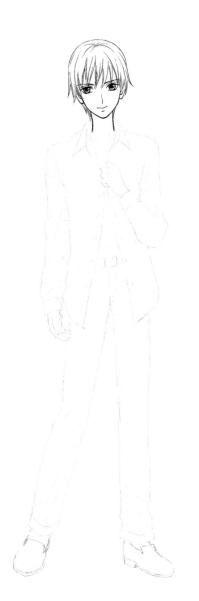

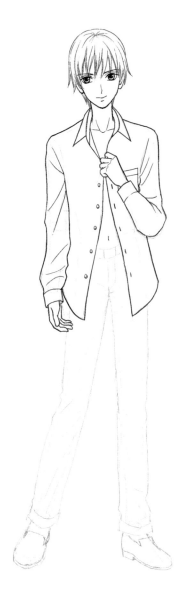

13. Ink his pants, using a finer-tipped pen for the creases.

14. Ink his shoes. Be careful not to smudge the close-together lines on the heel of his shoes.

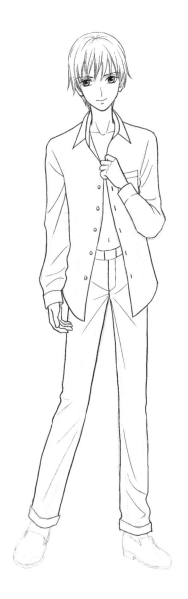

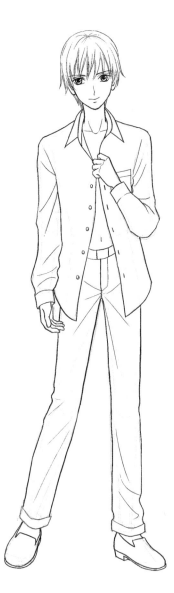

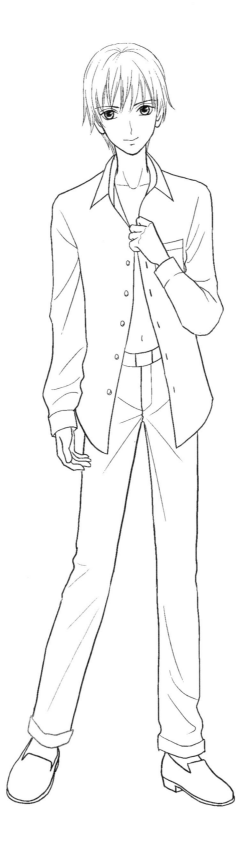

Yokai

Yokai are supernatural monsters and beings from old Japanese folklore. They make appearances in many manga, including *Nura: Rise of the Yokai Clan* and *Yo-Kai Watch*. Sometimes *mangaka* make up their own creations on how *yokai* should look, and sometimes they draw inspiration from old images of *yokai* in Japanese history. This particular *yokai* is called a *rokurokubi*, and can be found in old Japanese art, including works by the famous Japanese artist of the Edo Period, Hokusai.

1. Draw the basic outline. This *yokai* will look like a regular person for the most part, but she'll have a long, snakelike neck.

2. Once the outline is done, start on her clothes. Her hair outline will start with two curves on the side of her head, a headband-like shape over her head, and a larger shape behind that.

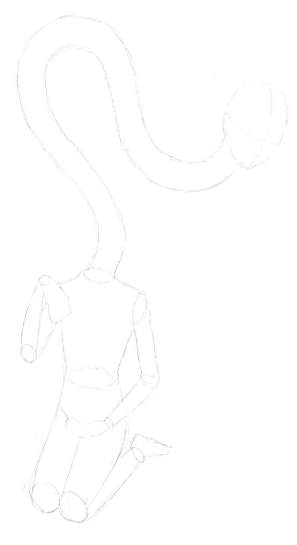

3. Fill in more detail for her hair, including thin strands of hair falling down her face. She is wearing her hair in a *marumage* style, which was popular with married women during the Edo Period. Most of her hair is pulled up and knotted in the back.

4. For her face, she has small, serious eyes and a soft mouth.

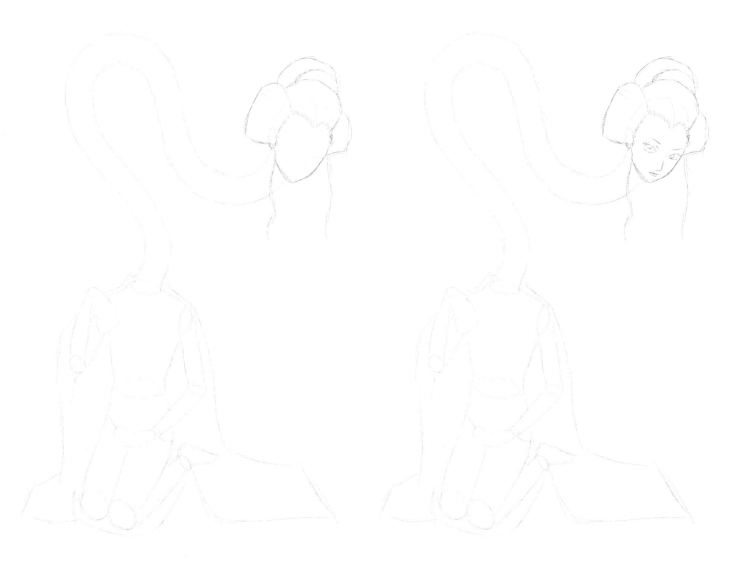

5. Draw her neck in more thoroughly.

6. Draw her hands. Her right hand (your left) has the fingers splayed with two on each side.

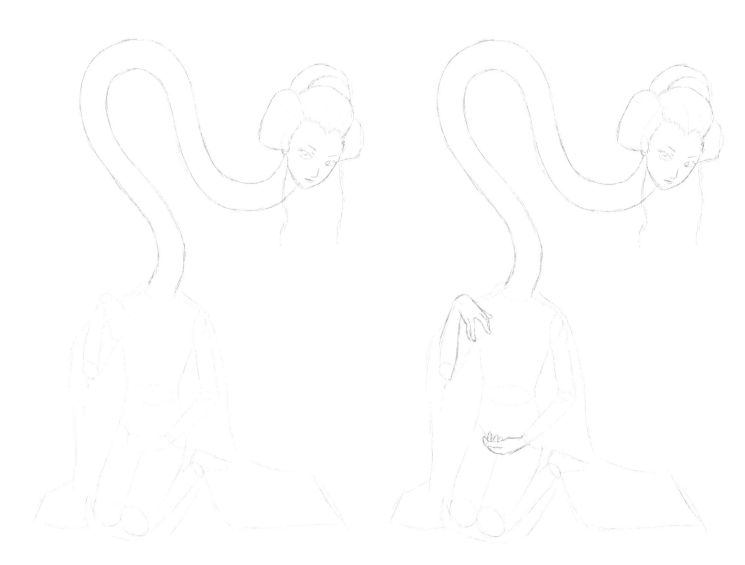

7. Begin your work on her kimono, drawing multiple lines to show the folds.

8. Finish her kimono with the long sleeves touching the ground. Be careful of the shape of the thin string belt on the wide belt of the kimono. Its knot can be a little complicated, so refer to the enlarged image for a closer look.

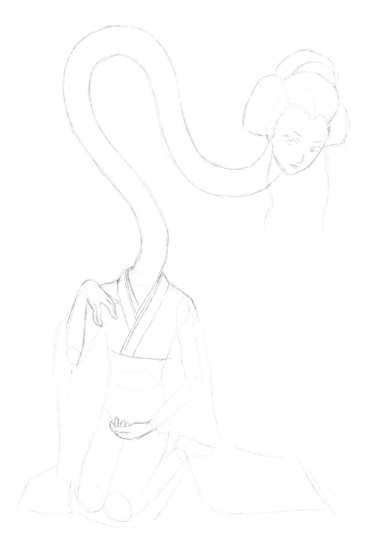

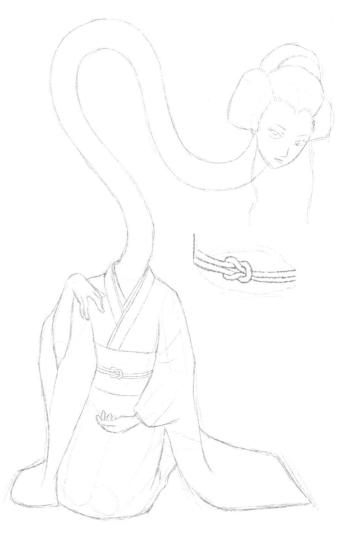

9. Ink her face, using a fine-tipped pen. Her look here isn't intense, but at the same time she looks dangerous.

10. Keep using a fine-tipped pen for her hair. To give it a real effect, the hair falling next to her face should be wispy with multiple pen strokes and the hair pulled back from her forehead should be slightly jagged.

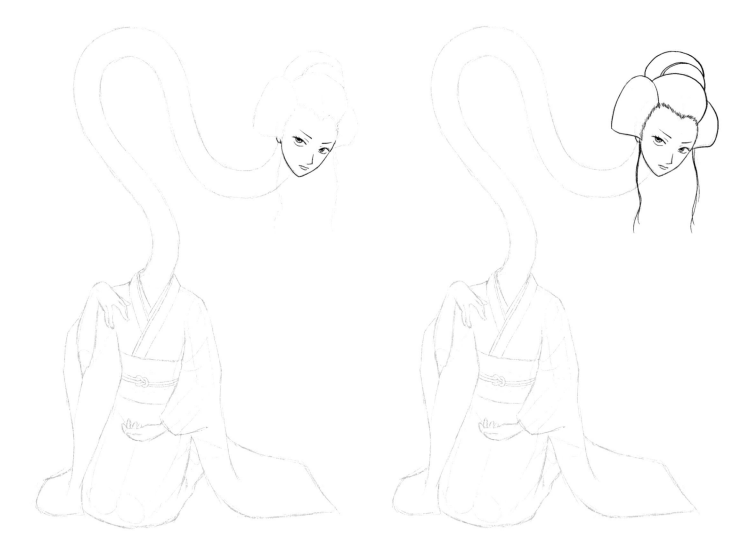

11. Using a thicker pen, ink her long neck. If it's hard to ink the neck line in one stroke, you can connect some shorter lines. To make it easier, change the angle of the paper freely every time you draw a curved line.

12. Ink her hands.

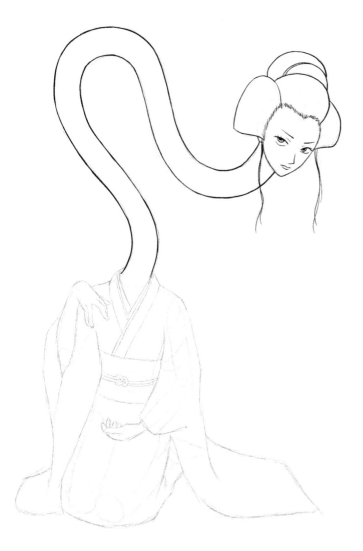

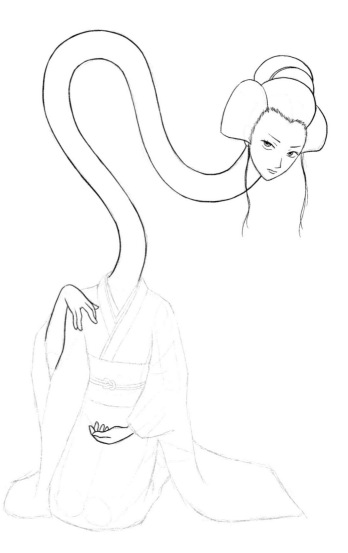

13. Ink her kimono, being very careful where lines are close together.

14. Return to her hair, and draw large spaces in each section of hair.

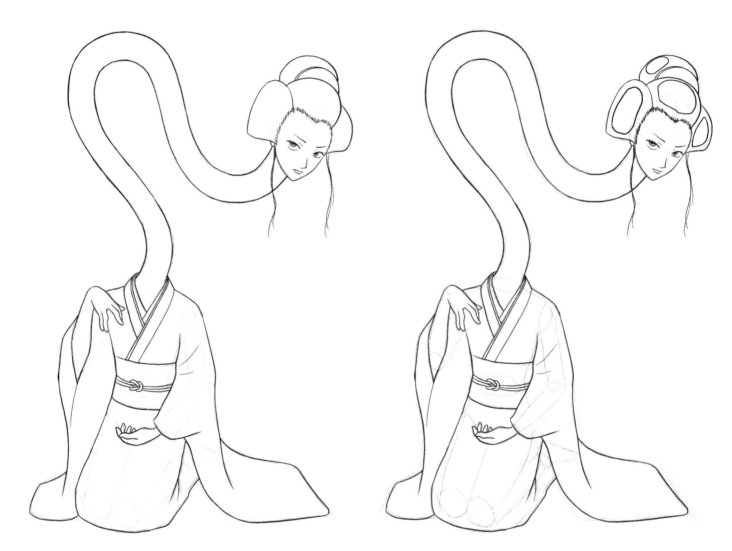

15. Erase all the pencil lines, then use an ink brush to color her hair. Leave the comb and the center spaces you drew alone.

16. From there, delicately go in and color more space, still leaving some white to give her hair a glossy look. You can also add more colors and screentones if you like.

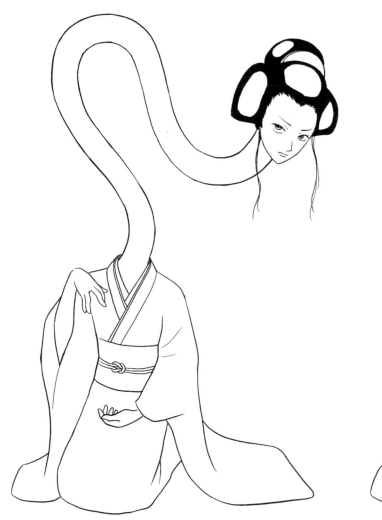

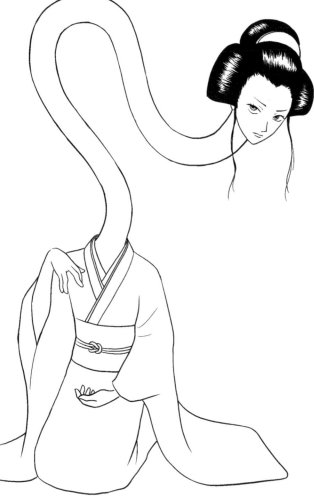

Make sure that all the pencil marks are completely erased before beginning to paint.

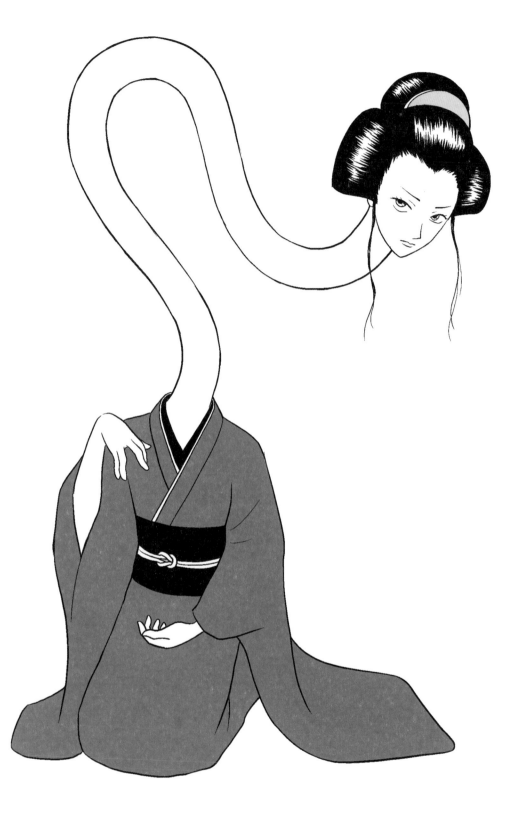

Soldier

Sometimes military conflict arises in manga, or characters have to defend themselves. From *Attack on Titan* to manga based on *Zelda*, fantasy-style soldiers can be quite popular.

1. Draw his outline, making sure to give him a strong posture. A large part of his right arm is hidden by his torso.

2. Begin work on his clothing and his weapon. In manga, it's not uncommon for characters to have large weapons to defend themselves.

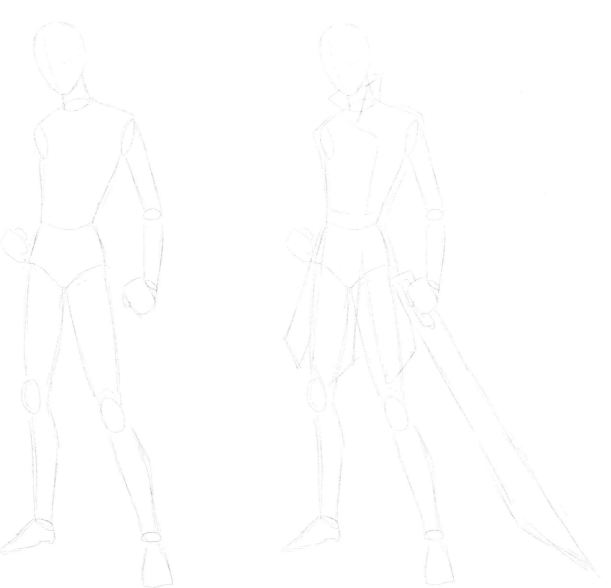

3. Draw his face. A soldier is probably a serious character, so he'd have smaller eyes to give that effect.

4. Draw his hair with longish, spiky wisps going over the side of his head.

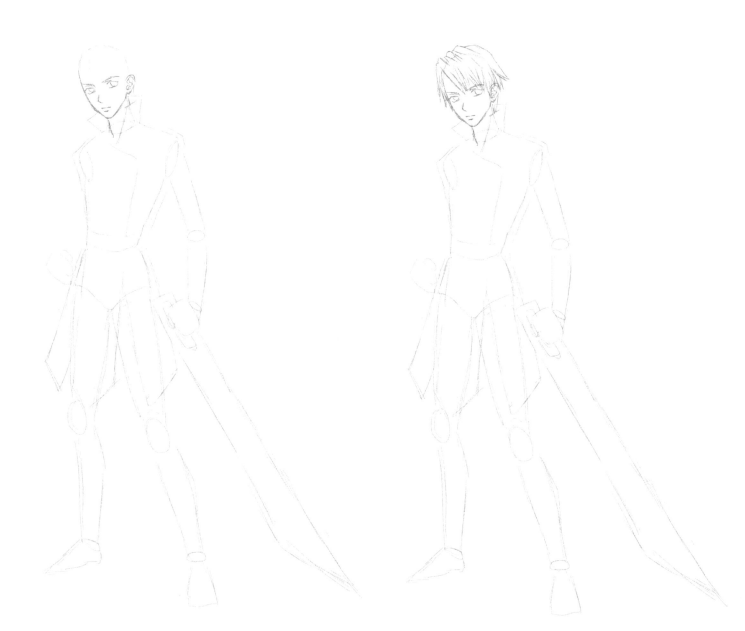

5. Start to draw his clothes. High collars are sometimes seen in military uniforms, and it's important for battle that a soldier's clothing is not loose and bulky.

6. Make his uniform look more soldier-like with epaulettes on his shoulders and a smartly buttoned-down coat.

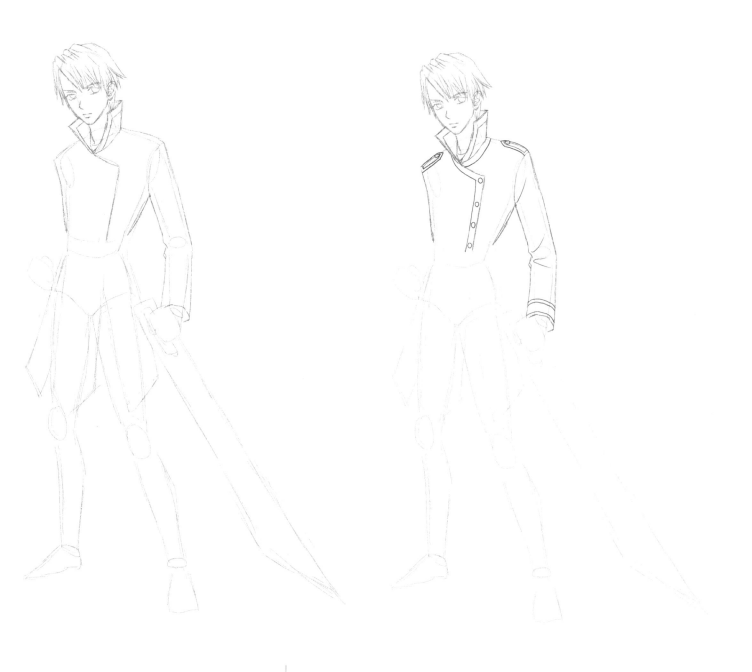

7. Draw the strap of his belt.

8. Draw the buckle.

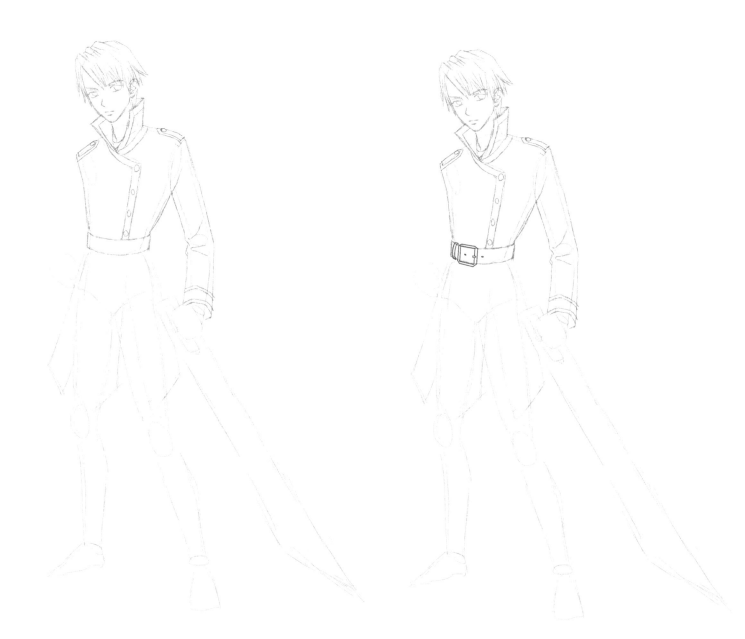

9. Continue the clothing below his belt. His shirt should come down and split open. The pant legs are tucked into his boots.

10. A soldier would probably be wearing boots as opposed to other kinds of shoes.

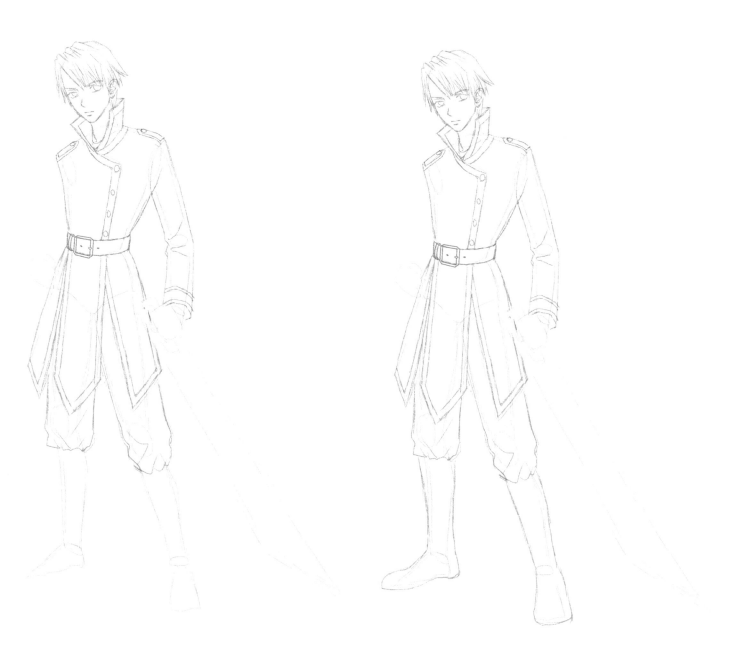

11. Add more detail to his boots by drawing a few lines.

12. Draw in his hands, closed as fists.

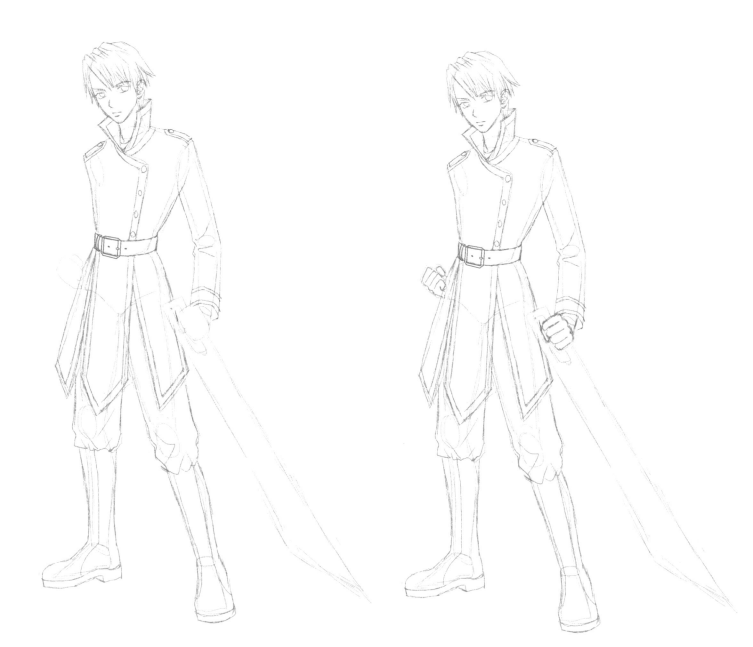

13. Now turn your attention to his weapon. First draw a rough sketch of it.

14. Once you have the rough sketch of his weapon to guide you, use a ruler to draw it in with straight lines. You can draw the curved part of the grip with a curved ruler, or you can carefully make that shape by hand.

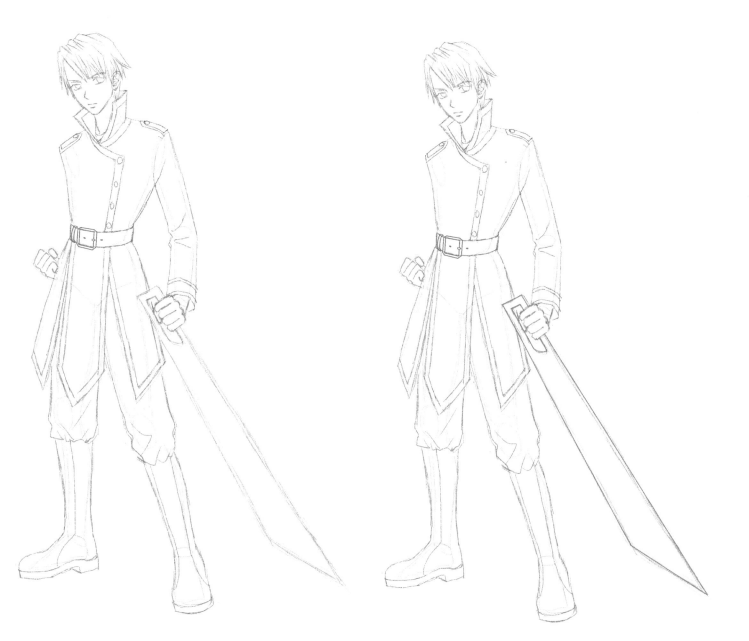

15. Add more lines to give the weapon a thicker look. Use a ruler to keep the lines straight.

16. Once he is all drawn, start inking his facial features.

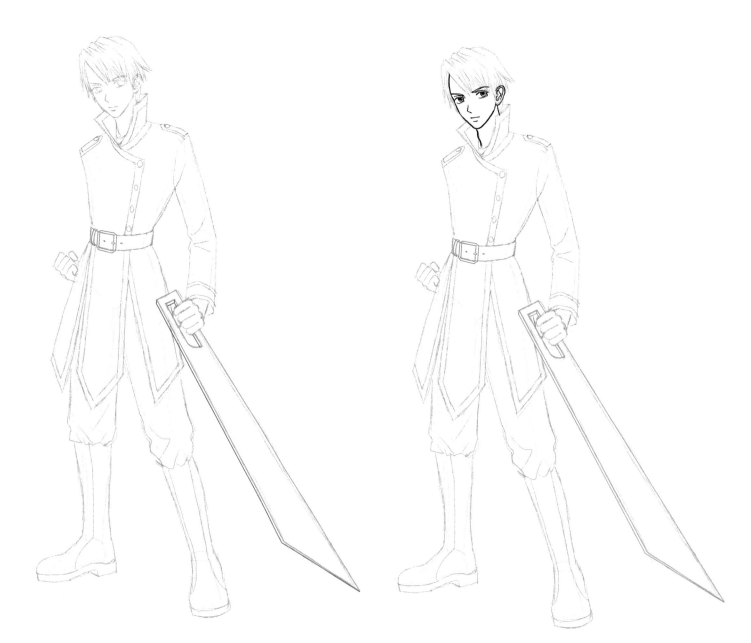

17. Ink his hair.

18. Begin to ink his clothes. Use a thinner-tipped pen for the creases.

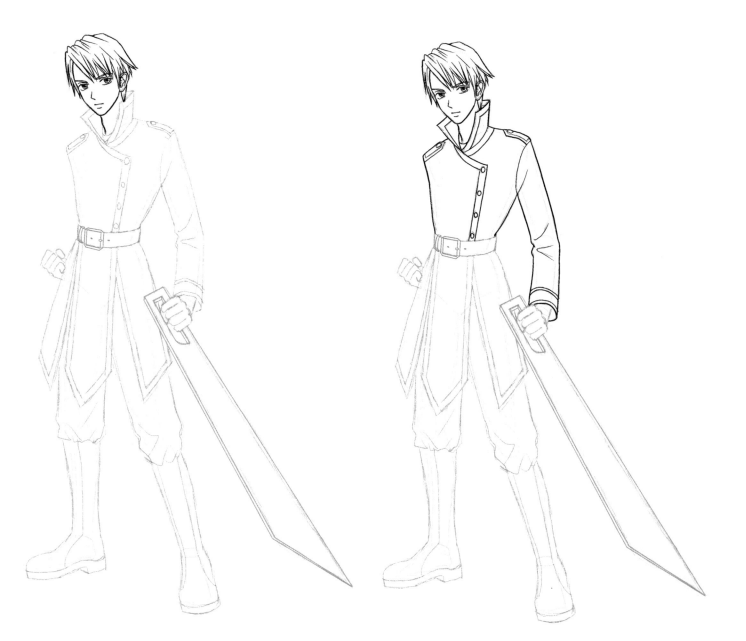

19. Ink his belt. Be careful going over small and close-together lines.

20. Ink his hands and his weapon. Also use a ruler when inking the weapon's lines.

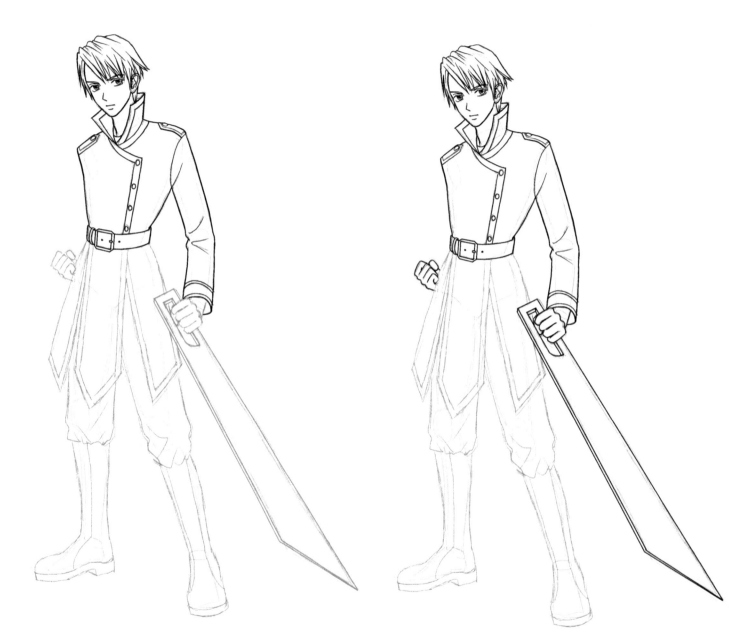

21. Finish inking his uniform.

22. Ink his boots and then do any extra touches you'd like.

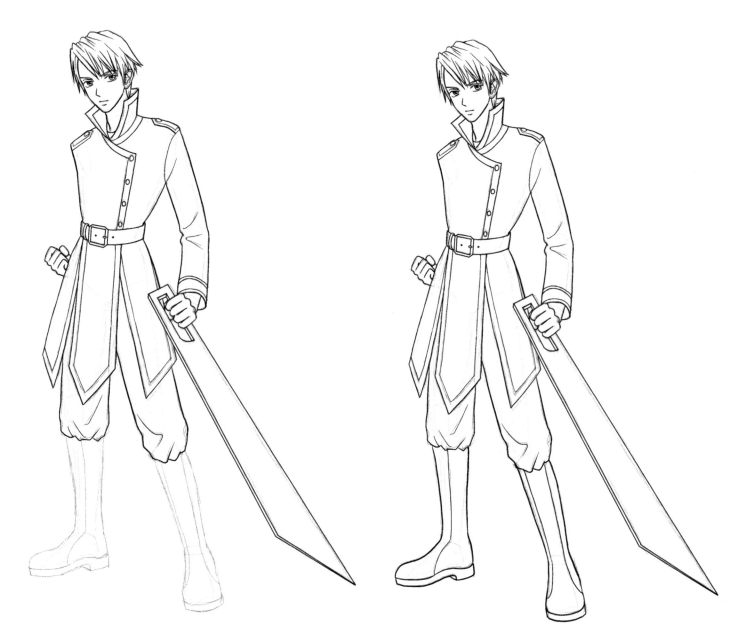

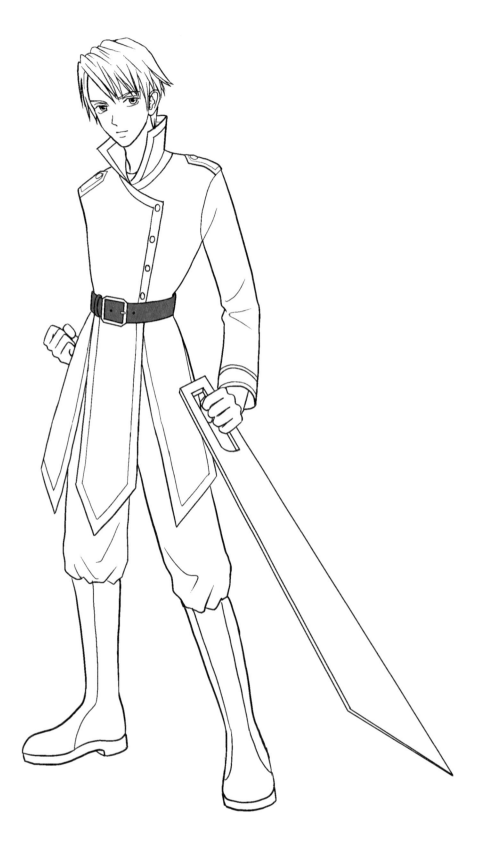

Victorian Man

Oftentimes manga take place in Japan, but other countries are explored as well. Victorian England is a bit popular beyond the new steampunk craze—it's the background for popular titles like *Black Butler* and *Emma*. Here's a manga-style Victorian man with top hat and cane.

1. Start with the man's outline. He's going to be holding a cane in one hand.

2. Draw the vague outline of his top hat, mantle, cape, and cane.

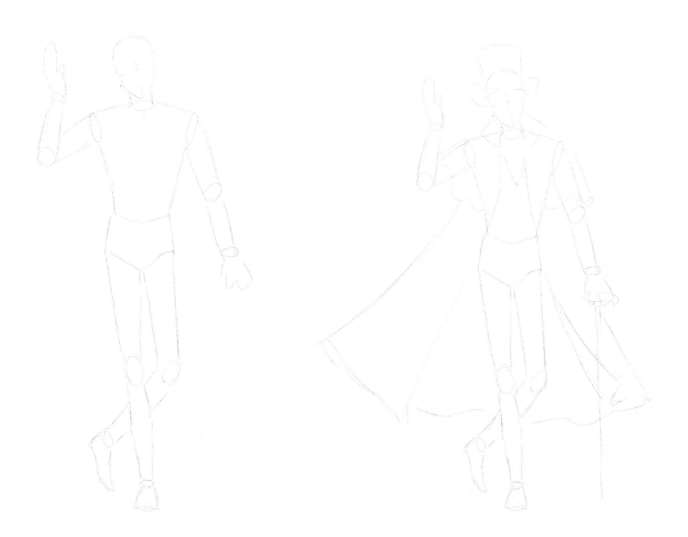

3. Since only part of his hair is seen, draw it together with his face. He has a slightly impish smile.

4. Draw his top hat.

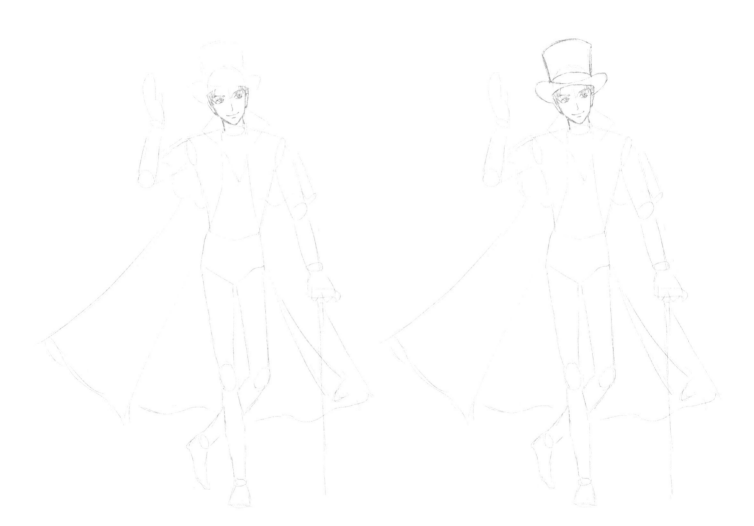

5. Draw his wing collar.

6. With a few lines, draw his ascot tie to give it a swelled look.

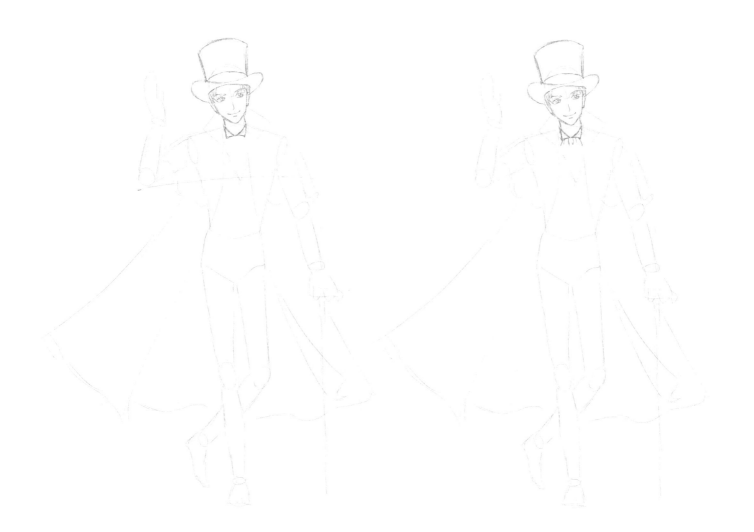

7. Begin work on his mantle. It will be tied across his chest.

8. Draw in his waistcoat with buttons.

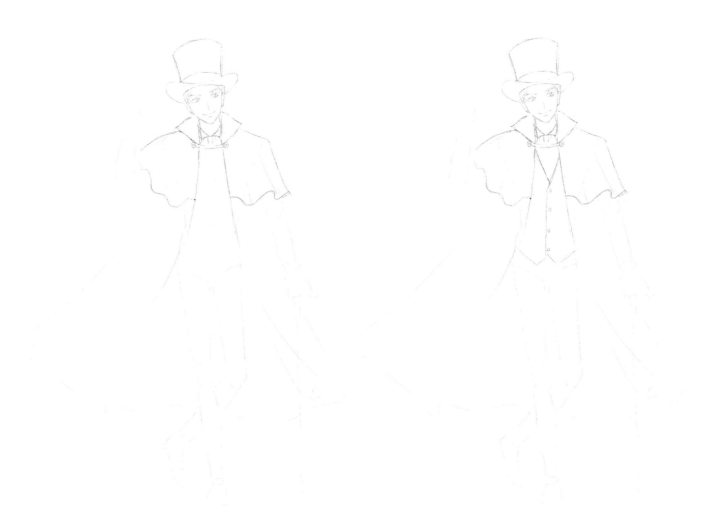

9. We're going to work more on the complexities of his clothes now. The sleeves of his tuxedo jacket are drawn under his mantle. On his midsection you can see his waistcoat and a bit of the tuxedo peeking out over it. The tail of his tuxedo can be seen behind him.

10. Draw his cane and his right hand. The grip on the cane should be drawn especially thin.

11. Once you've drawn his grip over the cane, draw in his fingers like this.

12. Draw his cape. It should move back from him as if it's being blown in the wind.

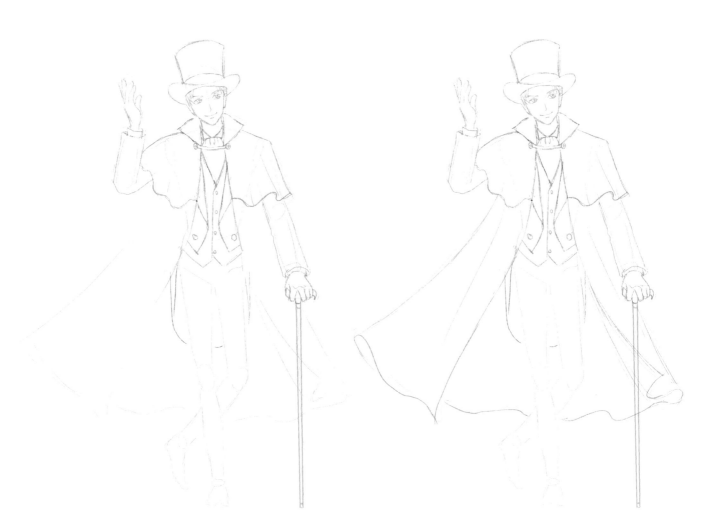

13. Draw his form-fitting pants. You don't need to put wrinkles in them because tuxedos are typically black.

14. For his shoes, the foot in front of him will be completely on the ground and seen from the front. The foot in the back will just be touching the ground with its tip.

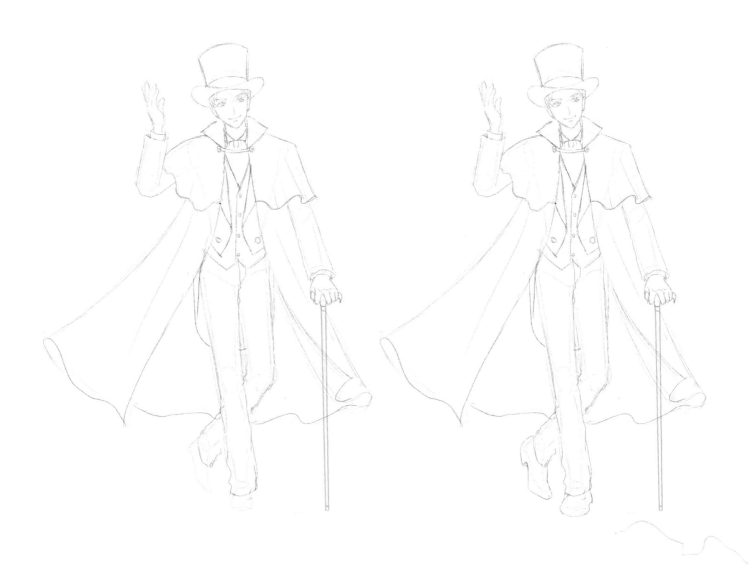

15. Start the inking process by inking his face and hair.

16. Ink his top hat. If you don't want to do the curved lines in one stroke, angle the paper then slowly and carefully connect smaller lines together.

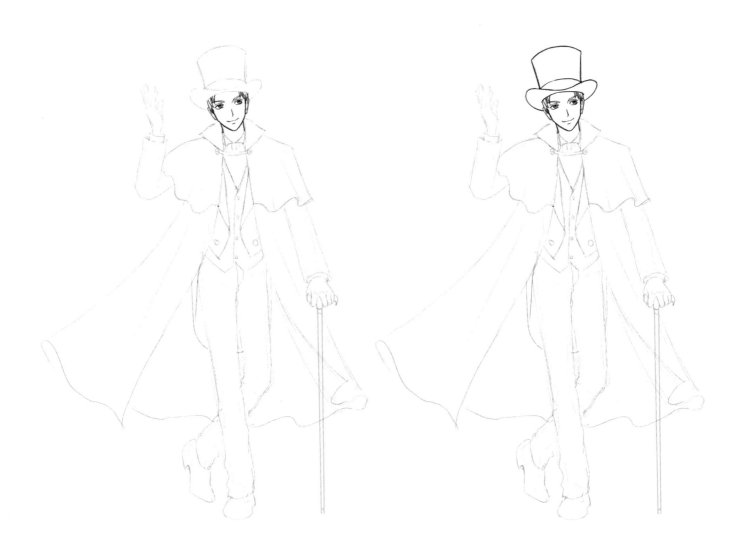

17. Begin to ink his mantle. Use a thinner pen for the creases.

18. Continue to ink his clothes. It's okay for the lines to go through the cane sketch if you want. This makes it easier to get straight lines, and you can use something like Dr. Ph. Martin's Bleedproof to take away the lines later.

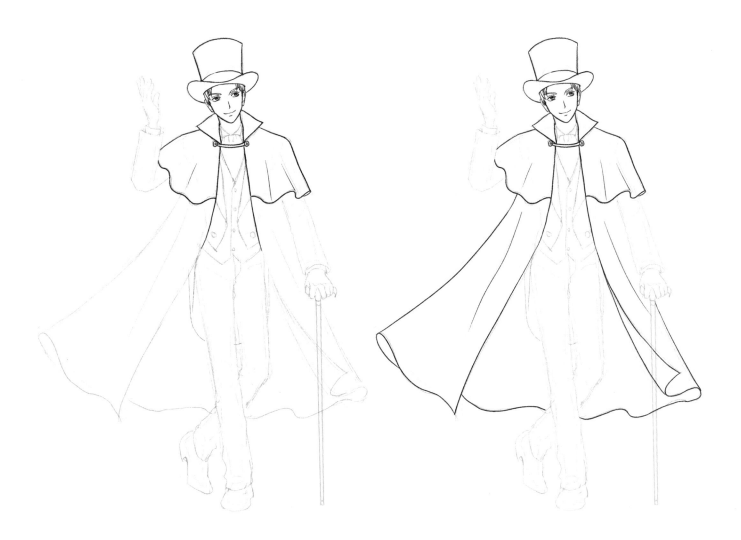

19. Start to ink in his waistcoat and buttons.

20. Ink the sleeves and the front body and tail of his tuxedo jacket.

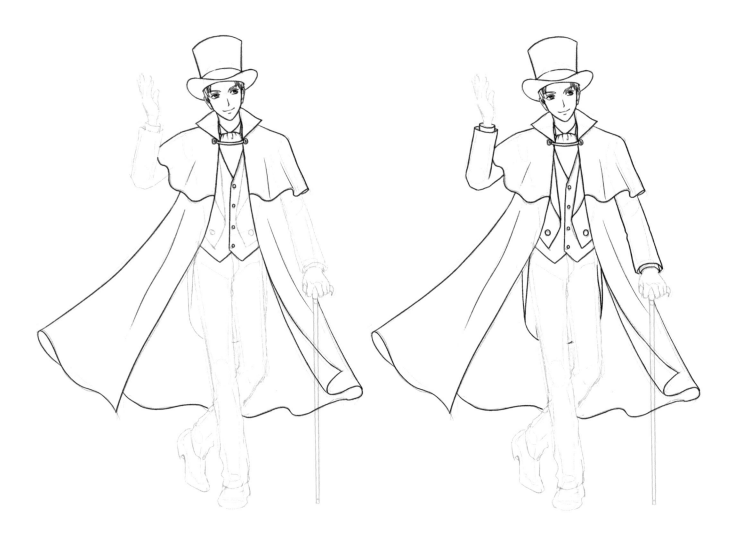

21. Ink his pants.

22. Ink his shoes.

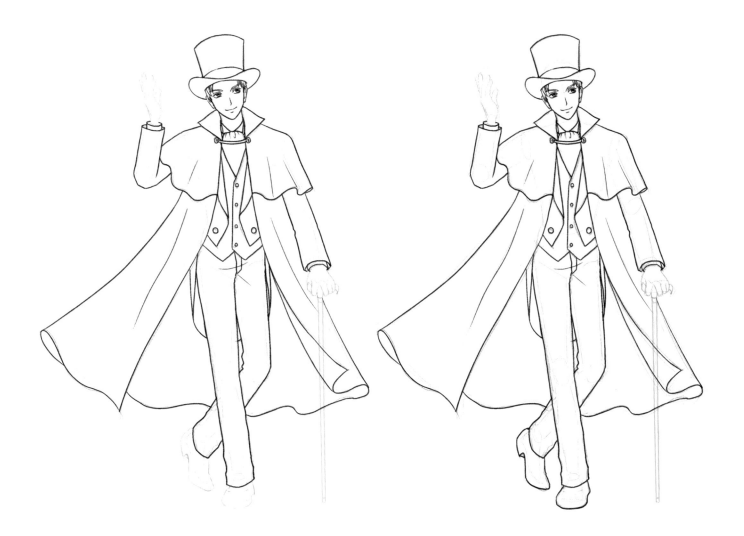

23. Ink his hands.

24. Finish the inking process by inking his cane.

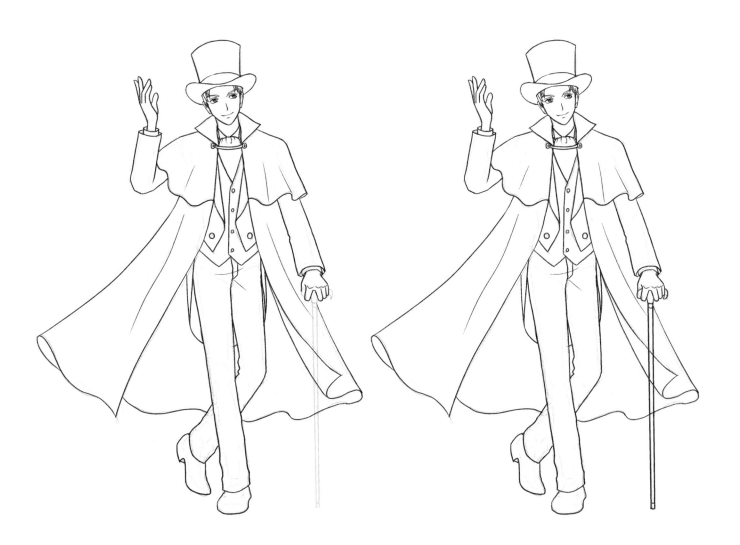

25. Once you're done inking, erase the original pencil lines. Paint his tuxedo black with software or a brush pen. Sometimes it can look a little different while inking, so you can add or delete lines. Here, the tuxedo tail has been extended very slightly to show how that works.

26. After the ink has dried, you can delete the extra lines in the cane and do whatever else you want, like adding screentones or putting white on the tips of his shoes to make them shine. Your Victorian gentleman is complete!

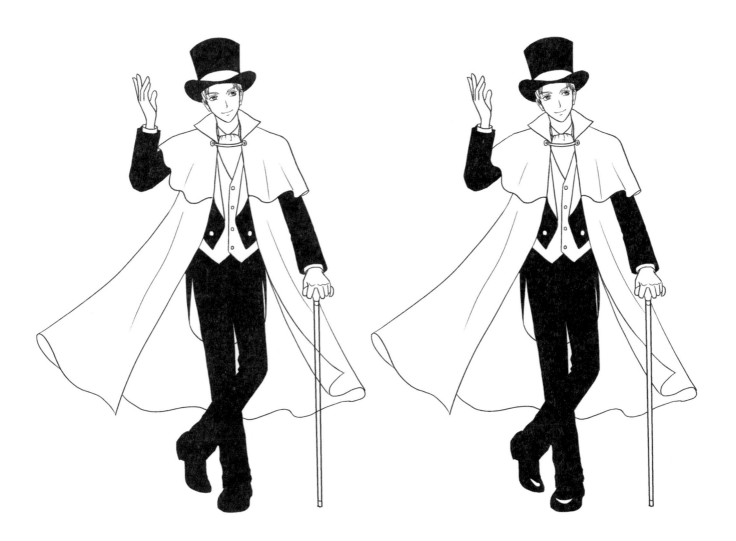

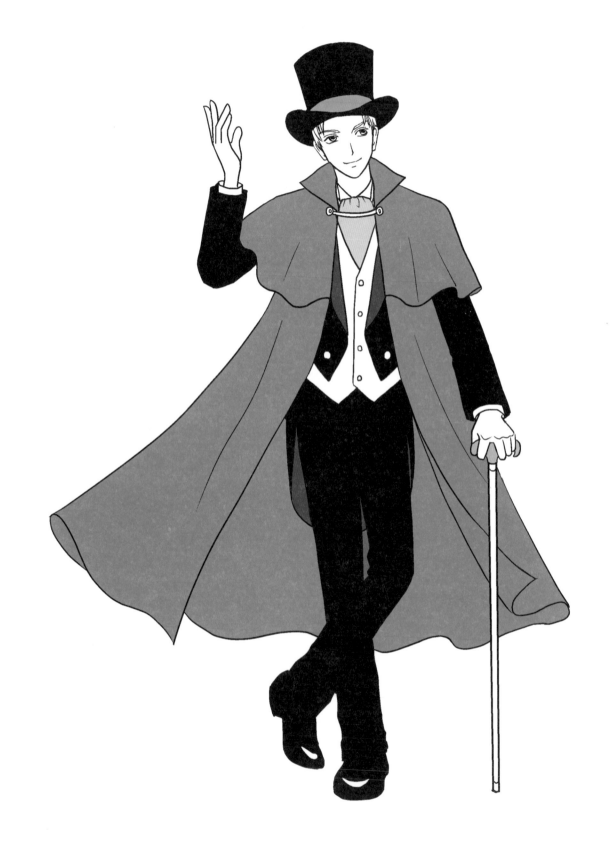

Heian Man

The Heian Period (794 to 1185) was an important part of Japanese history and shows up in historical manga. Here is a man in traditional and elaborate Heian garb.

1. Start with the outline of a man.

2. Draw in a large, vague outline for his clothing and the fan he's holding in his hand.

3. Draw his face. He has small, serious eyes.

4. Draw the tall shape of his hat.

5. Draw the first collar. Be careful of the position of the left part and right part. The left side of a kimono's collar will always be over the right, except when worn by the deceased.

6. Draw the thick collar of his robe.

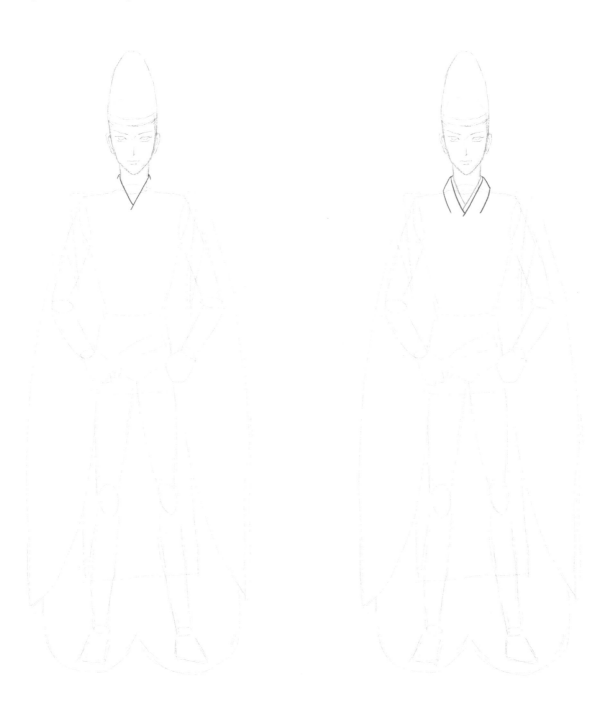

7. Beneath the collar, draw a thick half-circle.

8. Draw a broad-shouldered, vest-like shape over his upper body.

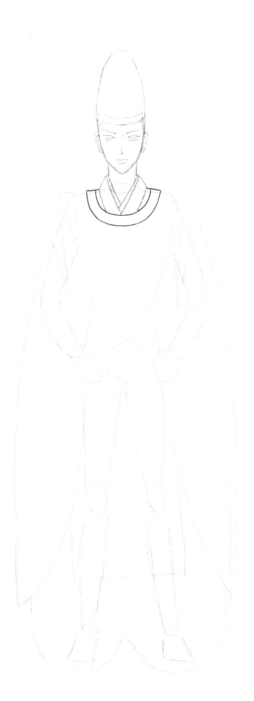

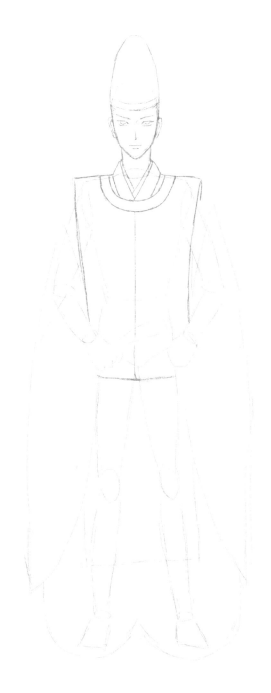

9. Draw his long sleeves. Make sure there's a line going inside each sleeve to give it depth.

10. Draw the lacing on the outside of his sleeves.

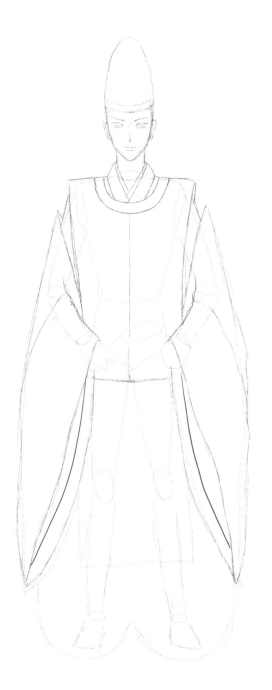

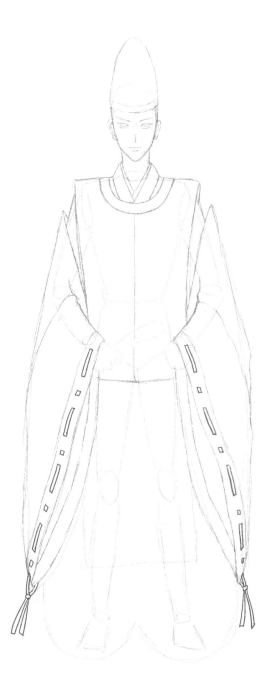

11. Draw the clothing on the lower part of his body.

12. His hands will mostly be covered by his sleeves. Draw his fingers at the tips of his sleeves.

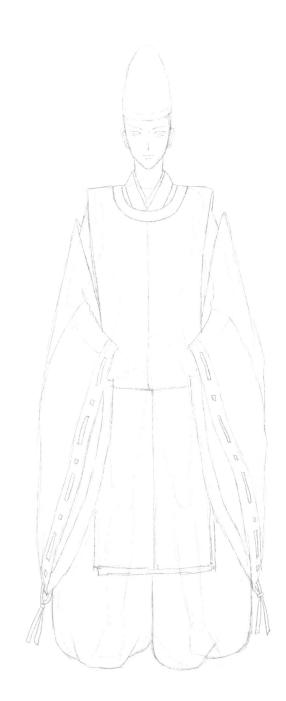

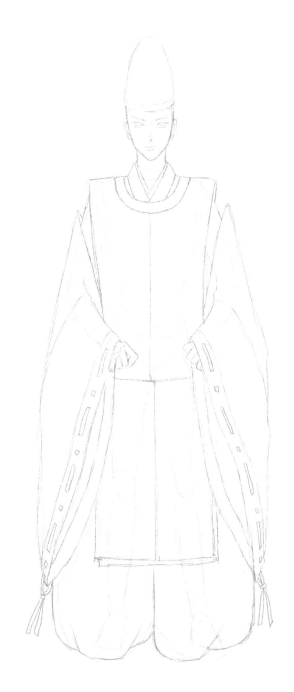

13. Draw the small fan he is holding; use a ruler.

14. Add depth to the fan.

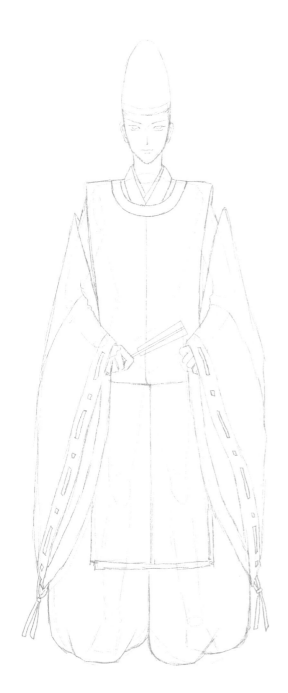

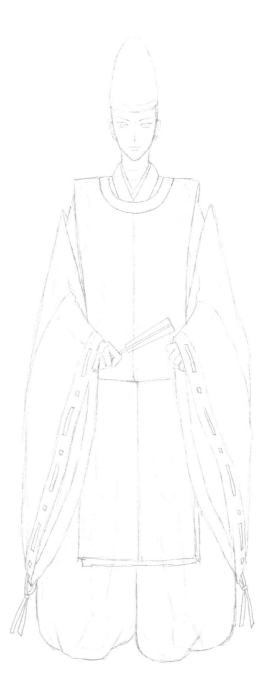

15. Begin to ink his face. Use a thinner pen for the delicate facial features.

16. Ink his hat, and ink in a little hair below it. Most of his hair will be covered.

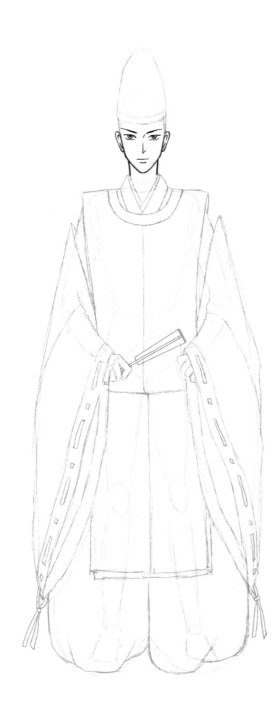

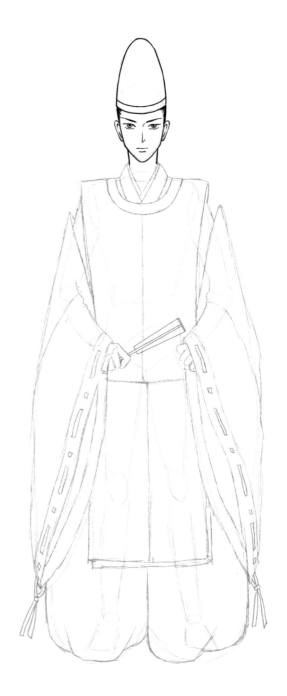

17. Begin to ink his clothing.

18. Ink his long sleeves.

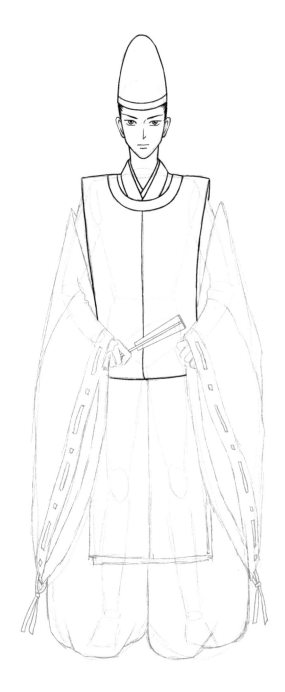

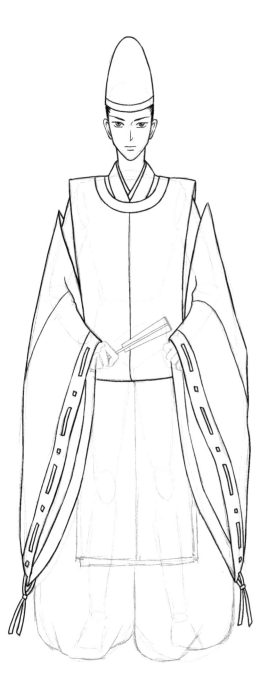

19. Ink the rest of his clothing.

20. Ink his hands, using a thinner-tipped pen for the knuckles.

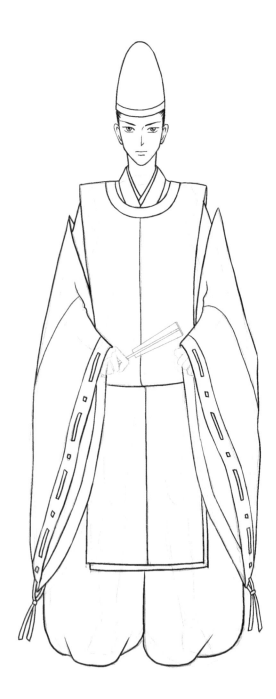

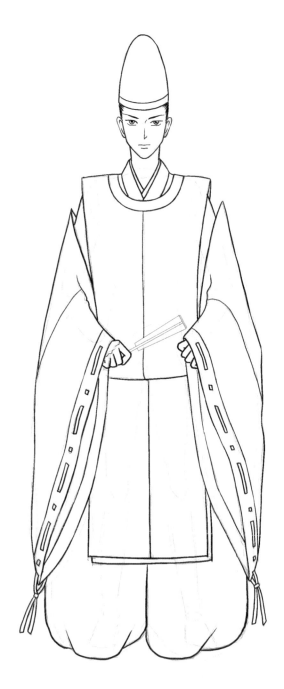

21. Use a thinner-tipped pen to ink his fan.

22. With software or a brush pen, ink in his hat, leaving a small white line.

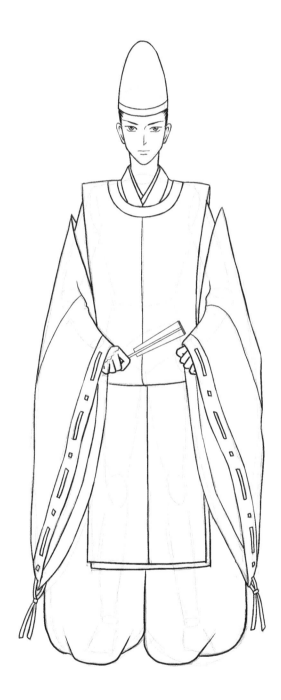

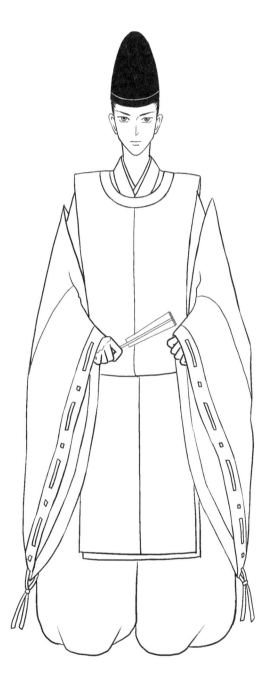

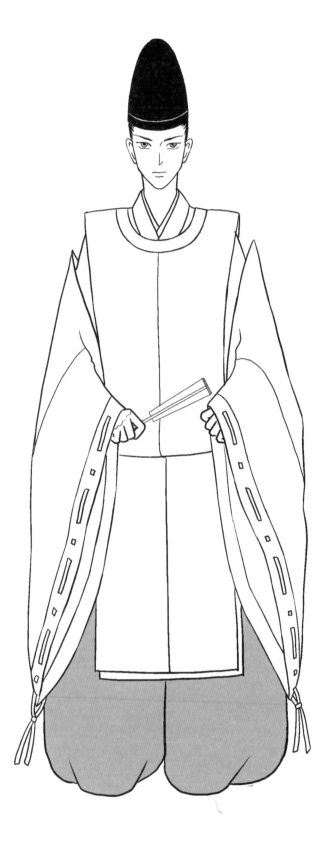

Female Warrior

Manga has plenty of warrior women who know how to fight and win. Sometimes they do it with the help of an oversized weapon, like this woman.

1. Start with the outline. Her shoulders are a little wider than usual to help give her a strong look. She is wearing heels, so draw her with her feet raised.

2. Draw the basic outline of her weapon. You can get imaginative with this, or use this weapon example.

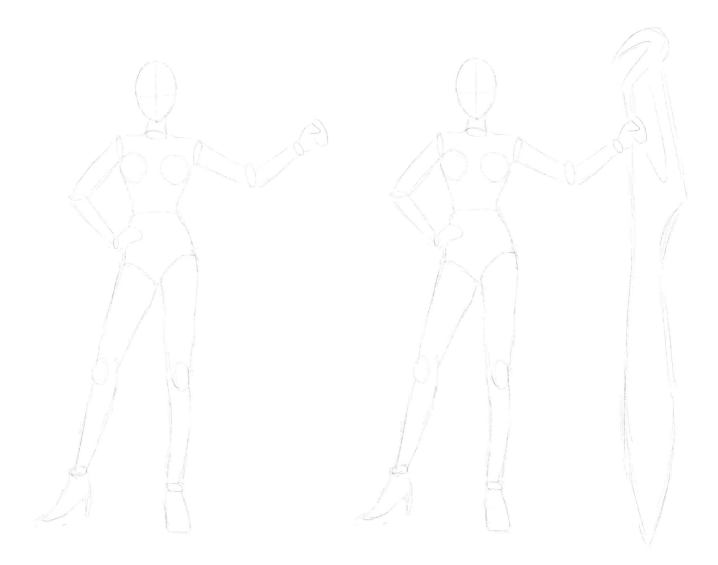

3. Draw her face. Her eyes are bigger than a real person's, but they're not as big as the eyes you typically see in shojo manga. The eyes will also be angled up to give her a tough look.

4. Draw her hair. Her bangs will just fall over her eyes, but the rest of the hair will stream from the part on her head.

5. Begin on her outfit. Oftentimes these female warrior characters wear low-cut outfits. The upper wings in the butterfly shape fit her like a bra.

6. Add more detail to her outfit below the "butterfly."

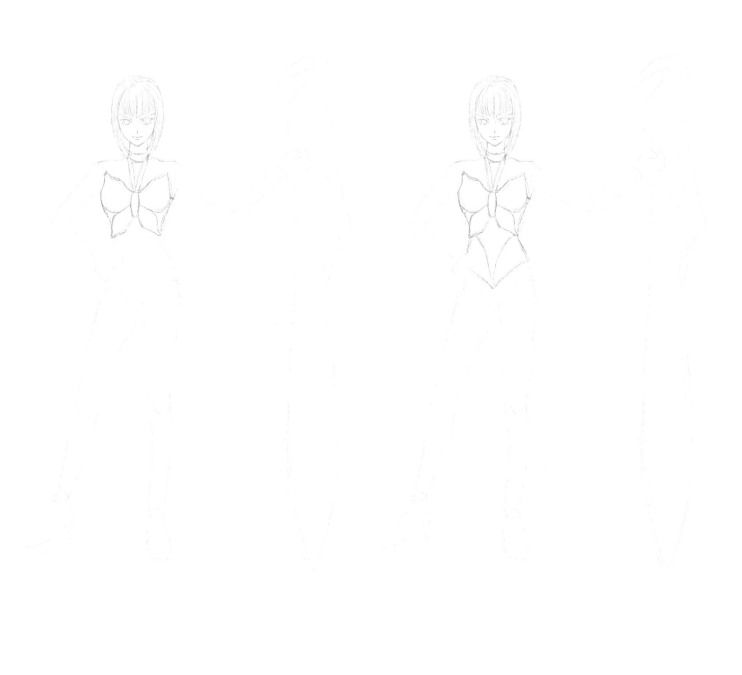

7. Draw her skirt, giving her pleats.

8. Her high-heeled boots go just above her knees. Because they are tight, they are basically her leg shape.

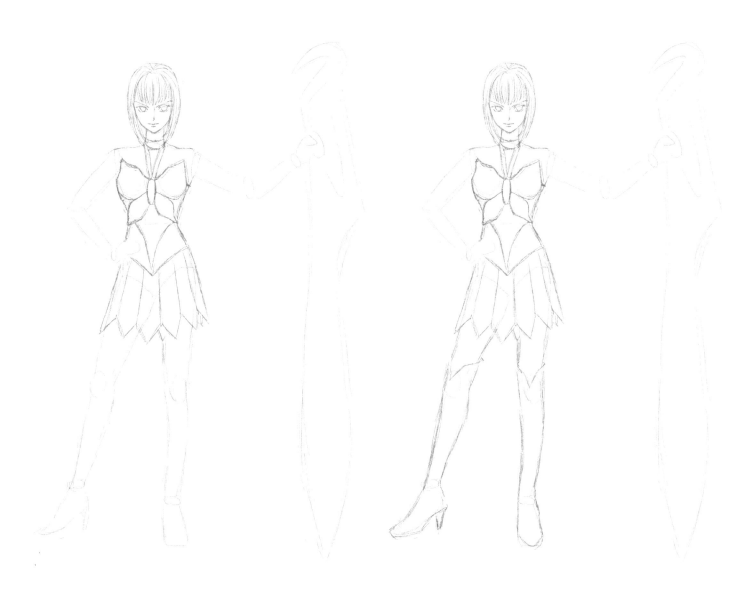

9. Draw her hands. Keep in mind the thickness of the weapon when you're drawing her hand gripping it.

10. Return to her weapon and sketch it in more thoroughly.

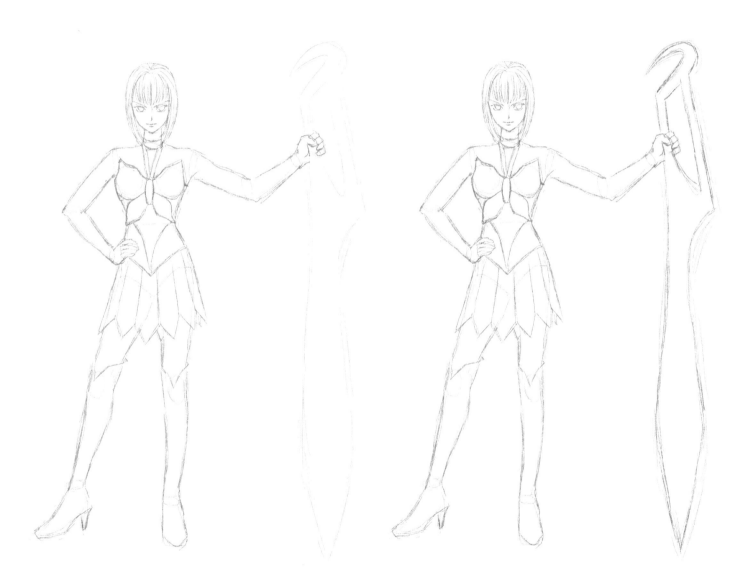

11. Once you are happy with the general shape of your weapon, use a ruler to make the lines completely straight. You can use a curved ruler or draw very slowly and carefully for the curved part. You can also change the design if you don't want any curves.

12. Using the ruler, add lines next to the weapon to give it depth.

13. Begin inking her face. Use a thinner pen for the delicate facial features.

14. Carefully ink the lines of her hair.

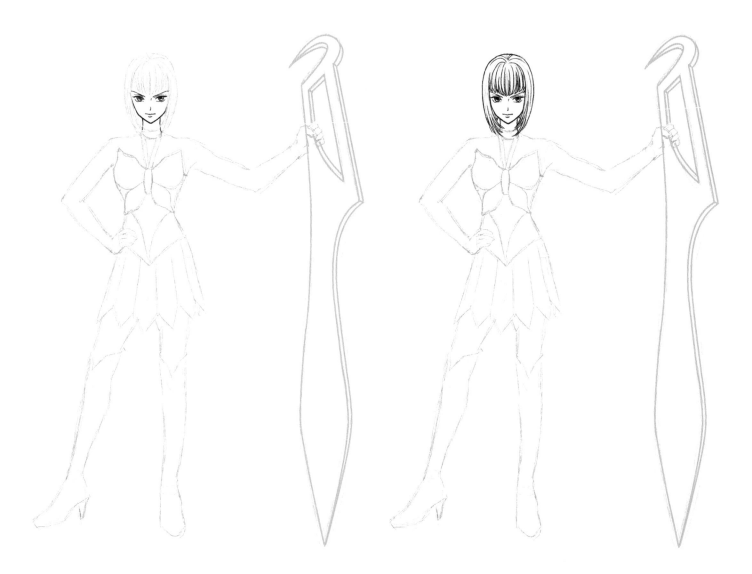

15. Begin to ink her shoulders and the top of her outfit.

16. Ink her arms and hands. Use a thinner pen for her knuckles.

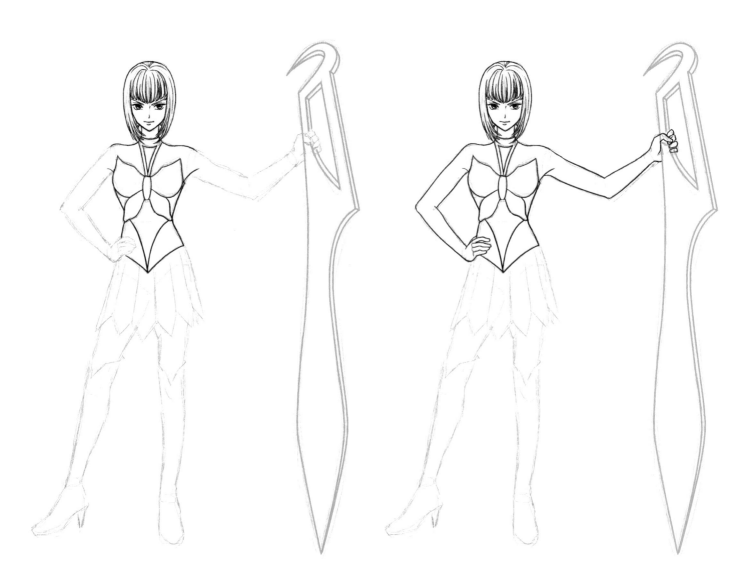

17. Use a ruler to ink her weapon. Before doing this, it's recommended you have some practice with inking with rulers, especially when it comes to the curved lines.

18. Ink her skirt.

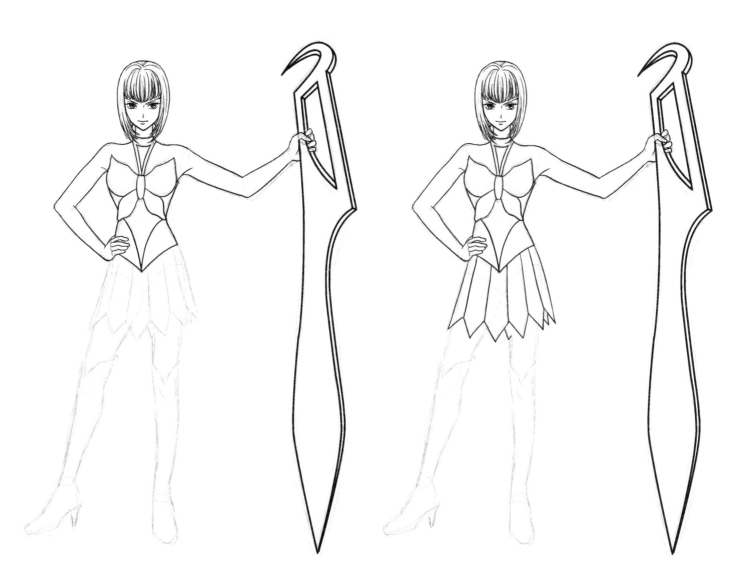

19. Ink her legs and boots.

20. After erasing the original pencil lines, you can ink in her hair, being conscious of how her hair streams. Leave some white parts.

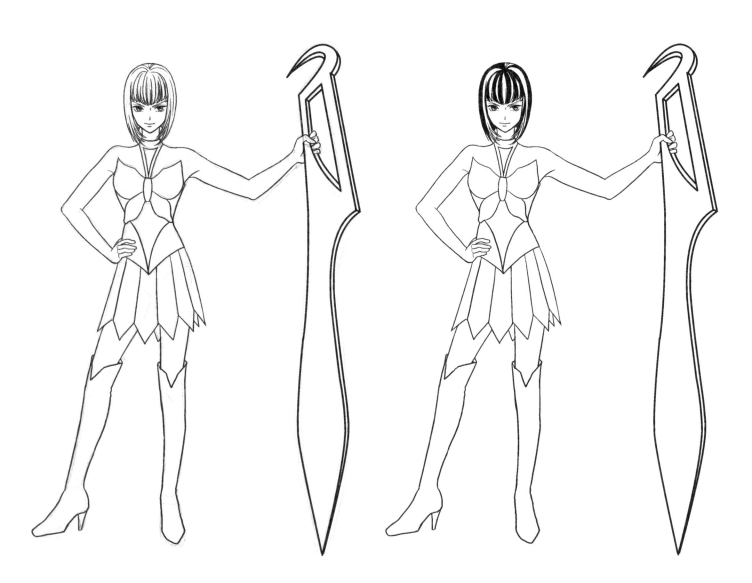

21. Using a brush pen, color in more of the parts you left white in her hair so you can give her a shining look.

22. Ink in her outfit as you would like.

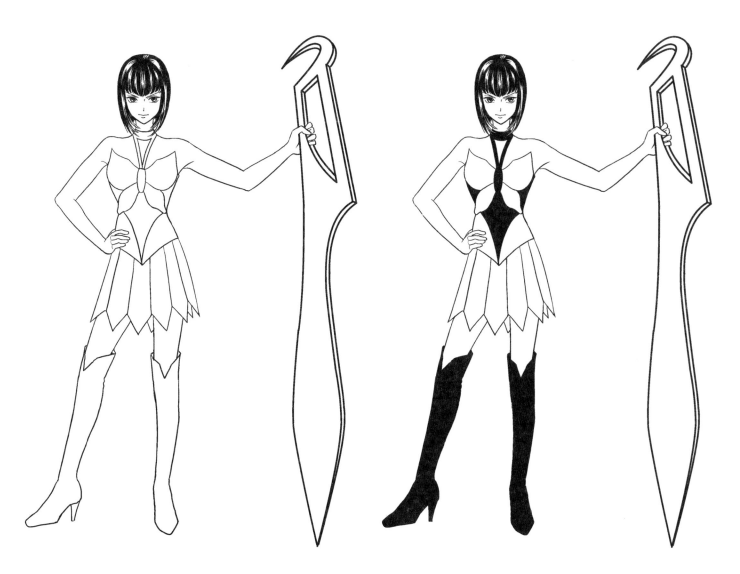

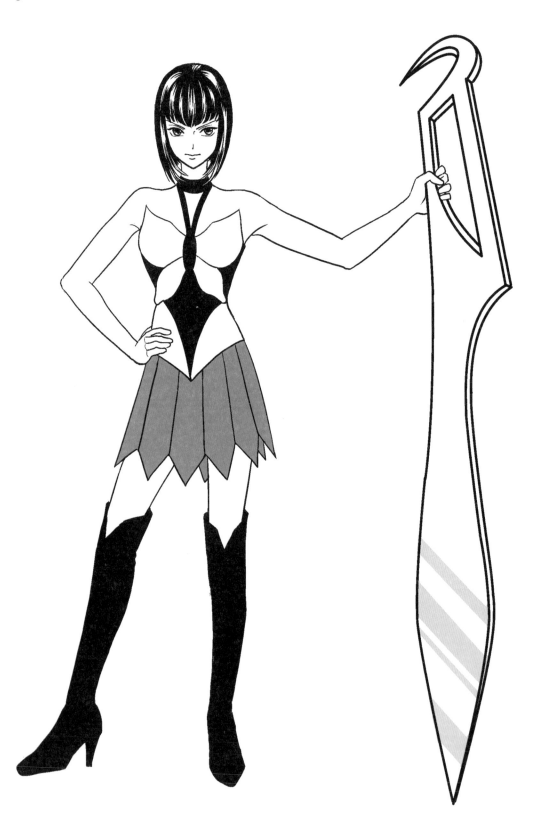

Tengu

Tengu are birdlike *yokai* from Japanese folklore. Like other types of *yokai*, you can follow the old style of drawing them, or come up with something new. Sometimes in manga a *tengu* will be portrayed as a mix of human and bird, creating an interesting twist to the old fables.

1. Begin with the outline of a man who has his arms stretched out.

2. Draw the outline of his clothes. His sleeves will be very long.

3. Draw the outlines of his long, flowing hair and the mask on his forehead.

4. Now draw in the outline of his large wings. The top of his wings will be higher than his head.

5. Draw his face. He has medium-sized eyes and a little smile.

6. Draw two straps covering his chest and stomach, and a small strap connecting them.

7. Draw fluffy pom-poms on him.

8. Draw in his long, deep sleeves.

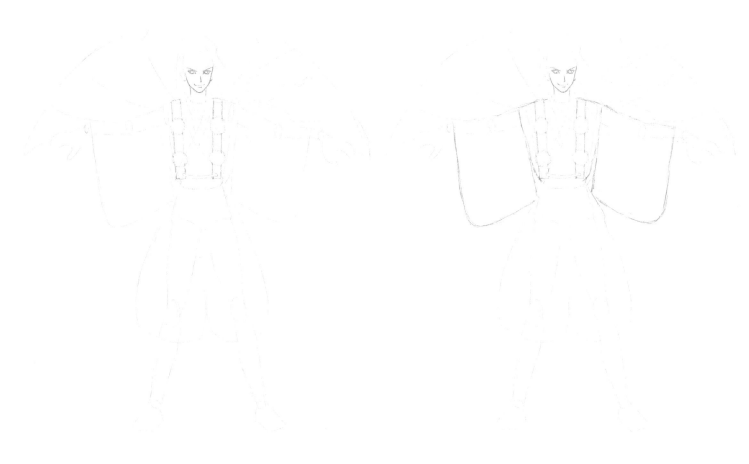

9. Draw his collar. His robe is folded over his chest, left to right.

10. Draw his hands. For this character, the hands are clawlike to give him a birdlike effect. Watch how the fingers arch.

11. His pants will be loose and creased at the bottoms. There's a ribbon tied around his waist.

12. Below his pants, draw in his legs and feet. His lower legs are covered with a wrapped material.

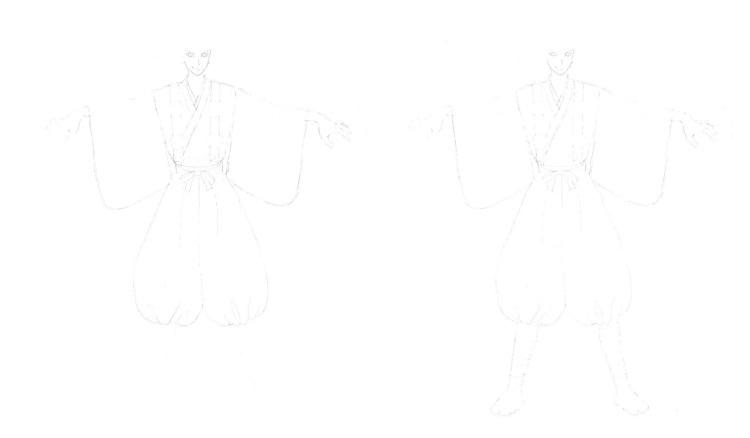

13. For his shoes, start with rectangles under his feet.

14. Draw straps over his shoes. These are called *hanao* in Japanese. His big toe will be separated from the rest of the toes.

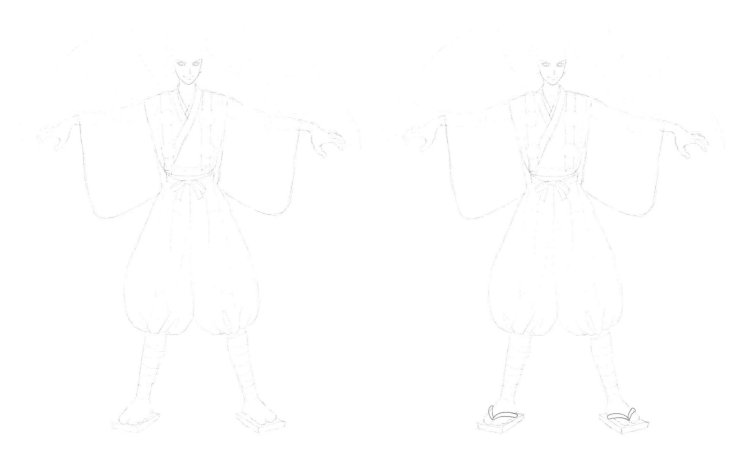

15. Draw in a block of wood under his shoes. The sandals he's wearing are called *tengu geta*, which are slightly different from regular *geta*, which have two wooden blocks underneath to walk.

16. Use a ruler to get the lines straight for the block of wood.

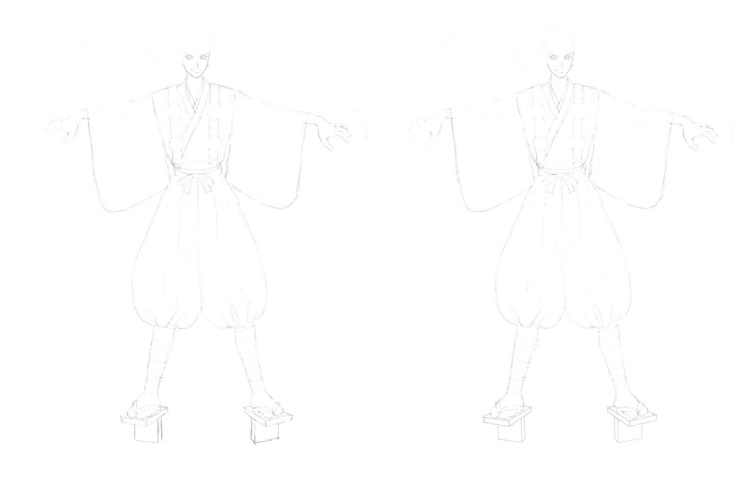

17. Turn to his forehead and draw the basic outline of his mask. The design is inspired by a crow to keep with the *tengu*'s birdlike theme.

18. Add more details to the mask. A line will go down his forehead with two little marks to the side. Feather-like prongs are around his head.

19. Draw his hair, being conscious of the long locks flowing in the wind.

20. Draw the basic lines of his wings.

21. Draw each feather along the blue lines.

22. Continue the pattern of drawing in the feathers.

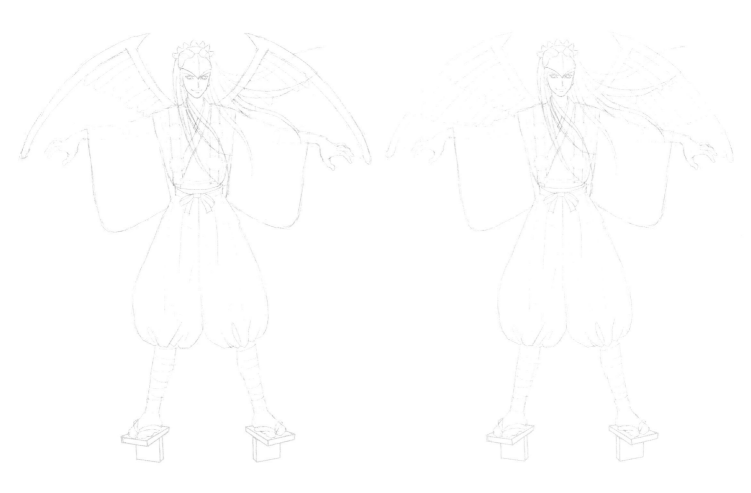

23. Finish the pattern of drawing in the feathers.

24. Before inking, you can erase the excessive, overlapping lines, like where his hair is touching his clothes.

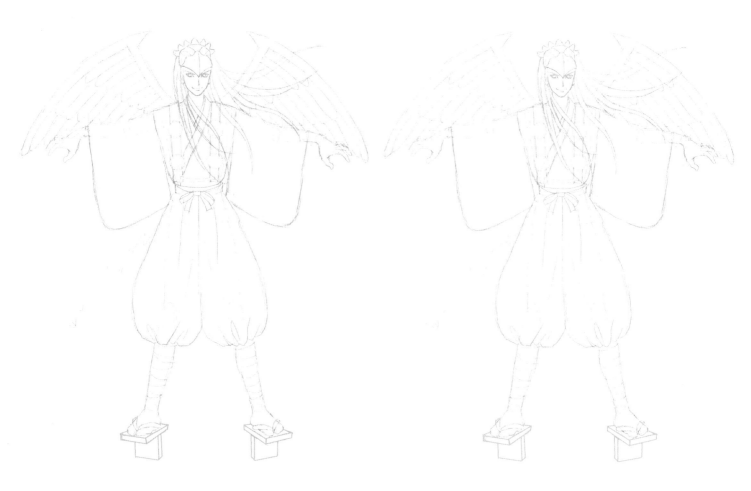

25. Inking starts with the face. Inking for him will go in a different order from how he was originally drawn.

26. Ink his mask.

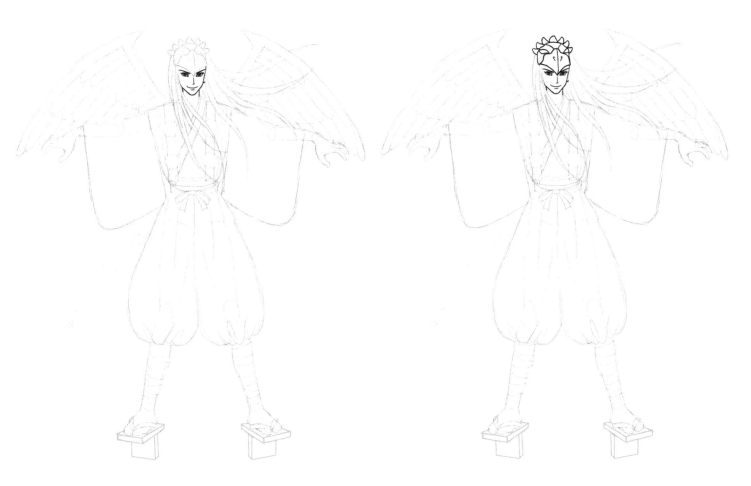

27. Because his hair is wavy, it's good to have some practice inking before you try this. Inking the lines in one long stroke takes practice, but it's also possible to do shorter, curved lines. If you don't ink exactly over your original hair lines, it's okay as long as it still looks good. After you've had practice, draw these lines more quickly than you would other lines to keep your hand from shaking.

28. Begin to ink his clothing. Be careful to keep the fluffy feel to his pom-poms.

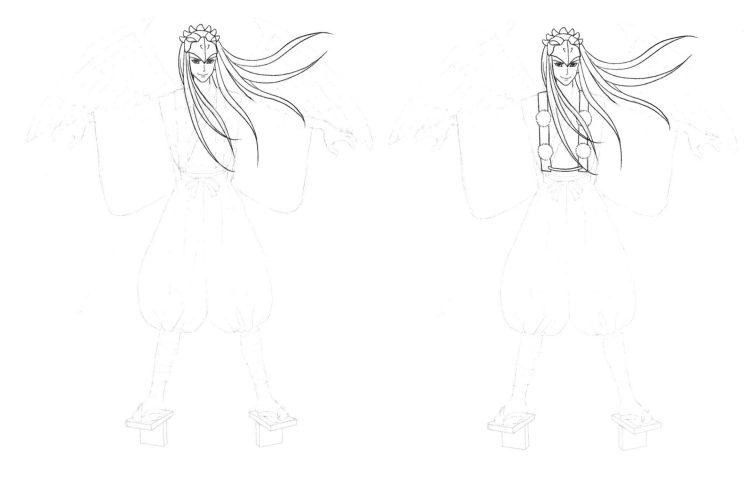

29. While you're inking, the right side of his collar (your left) will not be seen because of his hair.

30. Ink his long sleeves.

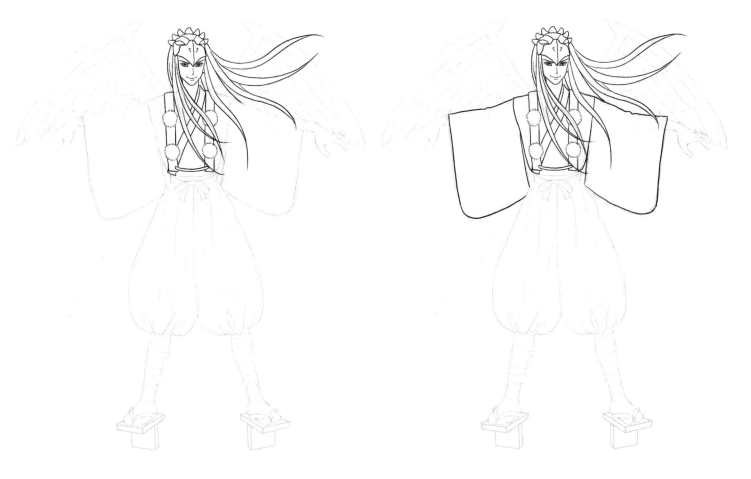

31. Ink his clawlike hands.

32. Ink his puffy pants and the creases.

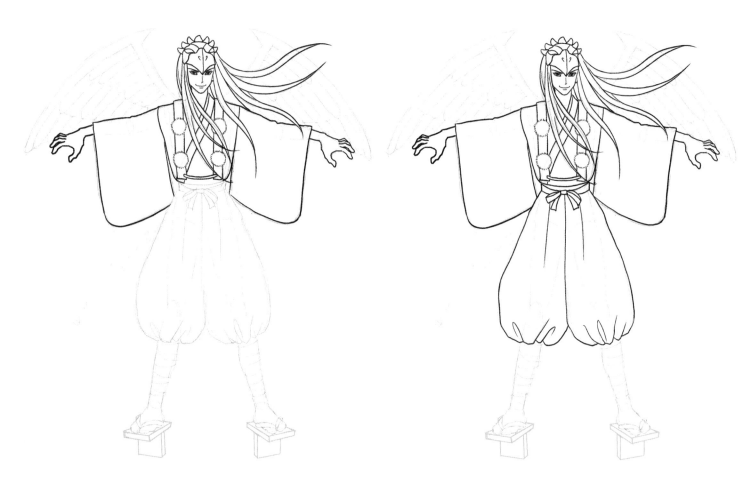

33. Ink the rest of his legs and his feet.

34. Ink his *tengu geta* shoes, using a ruler for the straight lines.

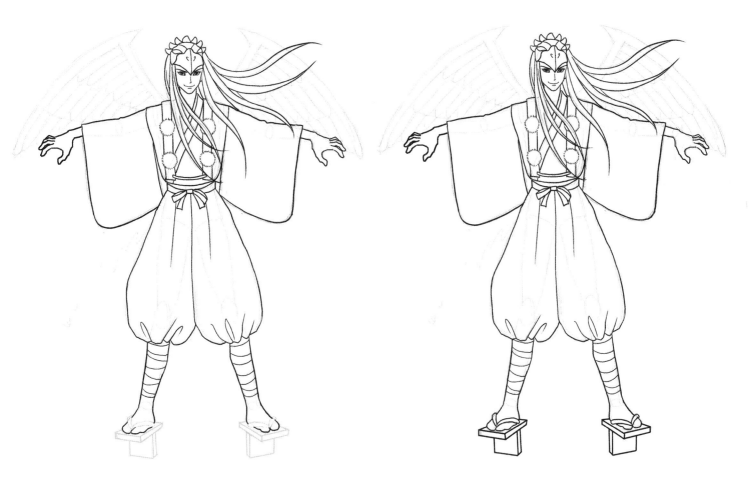

35. Ink his wings.

36. It's time to turn to his hair. Erase all blue and gray pencil lines, then paint the hair black.

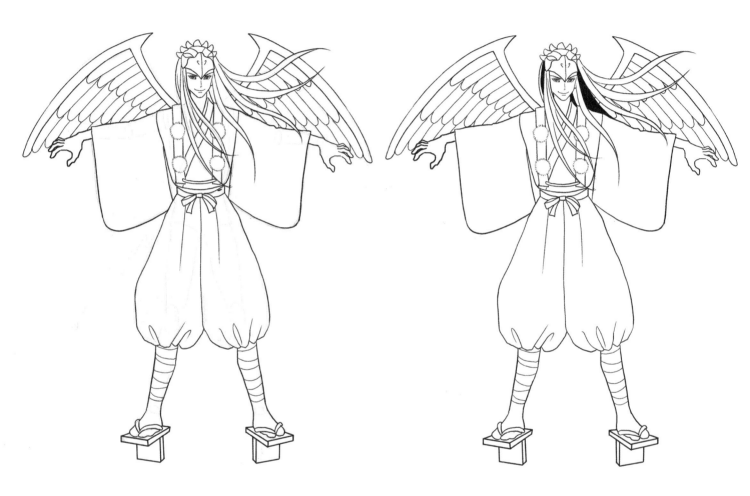

37. Using a brush pen, paint the remaining white parts of the hair, leaving shining white parts to make it glossy.

38. Paint other parts black if you'd like.

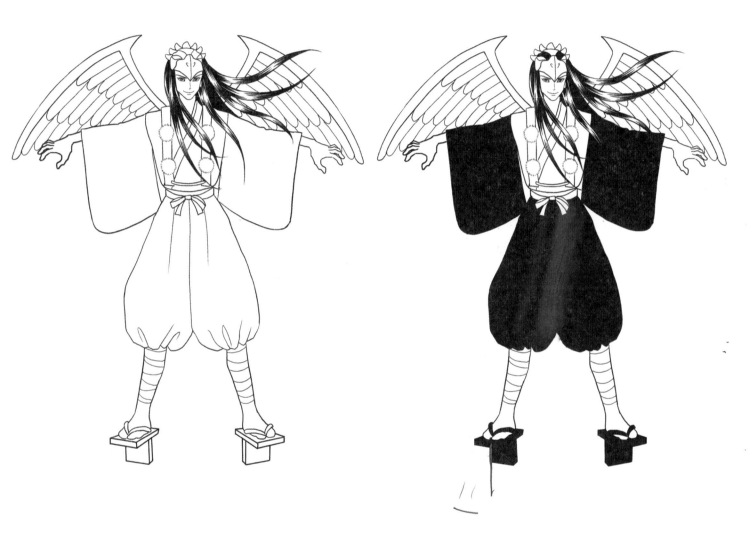

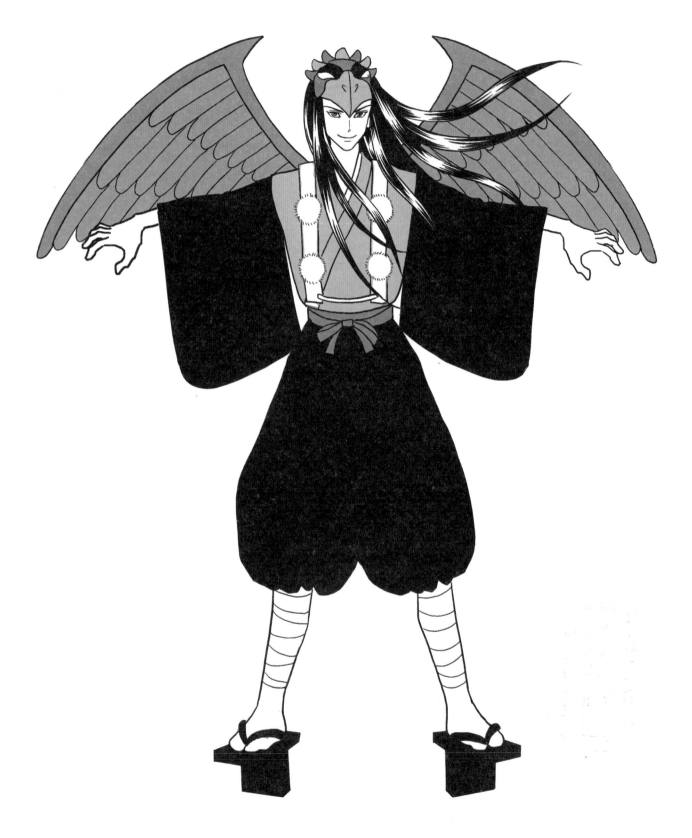